Sketching
with

ERIC
STEMP

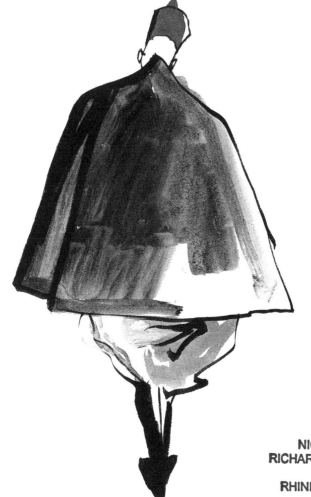

First published in 1988
by William Collins Sons & Co., Ltd
London · Glasgow · Sydney
Auckland · Toronto · Johannesburg

Reprinted 1989

British Library Cataloguing in Publication Data
Stemp, Eric
 1. Drawing
 I. Title
 741.2 NC710

ISBN 0–00–412306–9

Art Editor: Caroline Hill
Designer: Judith Robertson
Filmset by J&L Composition Ltd,
Filey, North Yorkshire
Originated, printed and
bound in Hong Kong by
Wing King Tong Ltd

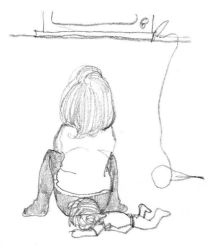

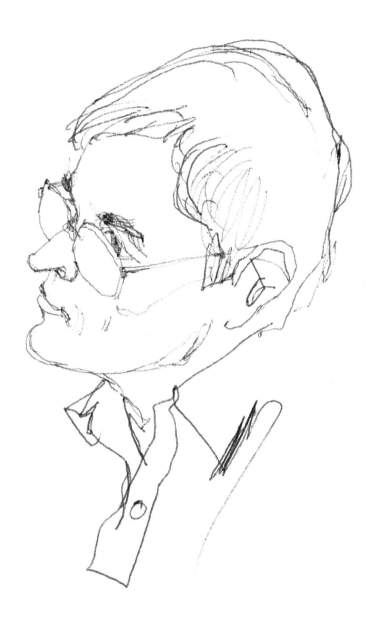

Eric Stemp attended Brighton Art School in 1939 and then joined the R.A.F. He was stationed in Germany from April 1945 until December 1946, where he did a lot of drawing and sketching. An agent saw one of his wartime drawings and soon after he commenced working as a freelance fashion illustrator. His work took him to Stockholm and New York, among other places. Eric Stemp worked for *Vogue* for seven years as fashion illustrator, and his work has appeared in many fashion magazines, including *Harper's Bazaar* and *Queen*. He has also worked for Simpson of Piccadilly.

Eric Stemp has designed two sets of stamps and several stamp book covers for the Post Office and his work has been exhibited at The Royal Institute of Painters in Watercolour. He is an associate lecturer at St Martin's School of Art, where he has been teaching in the Fashion Department for many years, and he lives in London with his wife and three daughters.

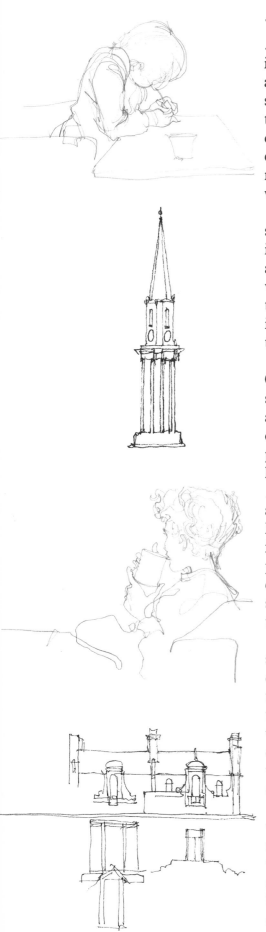

For a long time a sketch was generally regarded as an unfinished work of no particular merit, and certainly not eligible for exhibiting. Fortunately, over the years, that attitude has changed and now artists' sketchbooks attract a great deal of interest. I personally find sketches almost more interesting than the finished work – they are the 'bare bones' of a painting and show how the artist's ideas developed and how the picture was conceived. They also reveal that often the artist who drew or painted the picture one so admired, was not a consistent genius, but human after all; someone who started with basic scribbles and shorthand notes, like the rest of us.

The sketchbook is the working tool of the professional artist; somewhere to record ideas, places, colours. Sketchbooks are an important source of inspiration, but the sketches can also be works of art in their own right. It was interesting to discover that Rembrandt's very free, loose sketches were being given recognition as far back as the 1660s. His 'idea of drawing as an instantaneous reaction to visual inspiration, or impulsive expression of inner vision, seemed something new and stupendous to his contemporaries.'

Another famous painter whose sketches were acclaimed is John Constable, the great English landscape painter. C. M. Kauffman said, 'The sketch is central to Constable's art, and the essence of this art – the depiction of his natural landscape in a naturalistic manner – can be grasped much more readily in his sketches than in his finished paintings. Indeed, during the first half of his career, he painted hardly any finished exhibition pictures.'

All Constable's great paintings were based on long years of study and he made numerous sketches of animals, birds, trees, woods, landscapes, buildings, the movements of clouds and water, boats, farm implements and carts. Kauffman said 'whilst his contemporaries produced palatable art, Constable worked on studies – in the eyes of most of his contemporaries – unimpressive works. Today, we see them as transcripts of Nature – as such they appeal to those who trouble to see them in terms of personal observations.'

J.M.W. Turner was famous for the incredible number of tiny sketchbooks which he filled during his life – he did 1,800 pencil drawings of Rome and Northern Italy in six months! His output and the quality of his sketches was due to 'constant practice and unremitting observation. Sketching was his way of seeing.' Like Constable he would draw absolutely anything in his sketchbooks: landscapes, castles, mountains and even full-length nude studies. And he used a variety of mediums in his sketchbooks: chalk, pen, wash and watercolour.

Turner used larger sketchbooks when drawing commissioned works of the houses and parks of his patrons. These drawings were more carefully rendered and were used to give his patrons an accurate visual idea of the intended work. Turner's pencil sketches could be anything between a rapid note and a careful record that was also the basis for a complete picture. He was used to drawing in *any* weather, on occasions putting his head out of a coach window in a rainstorm,

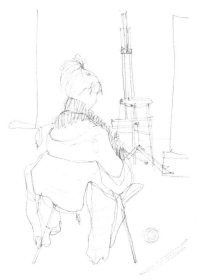

or being fastened to a mast during a storm at sea!

Pierre Bonnard, the French painter, always used his drawings 'to rekindle' his memory when painting. He, too, drew everywhere and at any time – often on terrible paper, old envelopes, or anything that was to hand. He drew incessantly on his daily walks in the country before breakfast. With his pencil he could catch 'life on the wing'. Bonnard used to say that when drawing 'your hand should glide like a shadow lightly over the paper.' He drew with a small stub of lead pencil so that he appeared to be drawing with his fingernails. Bonnard's sketches were mostly small, like Turner's and it seems that these two artists used their pocket-sized sketchbooks like a mini-camera of today, taking them everywhere. They were conveniently small enough to go into a pocket, so that notes and sketches could be constantly made 'on the spot' without attracting attention.

There are different kinds of sketches

There are so many different kinds of sketches: varying from rapid notes – a few energetic lines, or slight indications – to carefully executed and detailed drawings which are an accurate record. They can be sketches you do for fun and enjoyment, as preliminary work for paintings, or indeed, working drawings which often have almost as many words on them as drawn lines. Most sketches usually have one thing in common, though: they are invariably done *quickly*. It is this that gives them their special quality of freedom and spontaneity. In fact, you could say that the essence of a sketch is not so much that it is unfinished, but that it has simply stopped at the right time.

There is a difference between a sketch and a drawing, or study. As the word implies, a study is a careful, detailed drawing. You will notice the difference in these two examples of a sketch (above) and a study (below). The study has a 'finished' quality about it, unlike the sketch which reflects a sense of urgency. Often a few rapid lines may capture the essence of the subject more graphically than an over-worked, laboured study. A drawing is something that one expects to show to others, or even to exhibit, whereas a sketch is more private. In a sketchbook you are simply recording something which interests or attracts you and it is more like a personal, visual diary.

Of course, there is not the urgency involved when you are sketching landscapes, seascapes, or buildings as there is when drawing animals and people, who are likely to move at any moment. Most of my sketches in this book involve people as I have always been attracted by the human figure as a subject for drawing, rather than inanimate objects, but everyone has their own preference. On the other hand, it's easier to draw things that don't move!

When you start to sketch your first efforts may not be exactly what you had in mind. It is only natural to have the preconception of a 'nice' drawing on the page, but even professional artists don't always get it right first time when sketching and drawing. Remember, you are not trying to make a perfect picture, you are simply trying to record your impressions in pencil, or pen, and a sketch can be just a few lines. The important thing is that it is *your* impression, no-one

else's. *Never* use an eraser, because if you are concentrating and drawing rapidly, you won't have time. Anyway, you should simply correct the line with another beside it, thus building up form and body in your sketches.

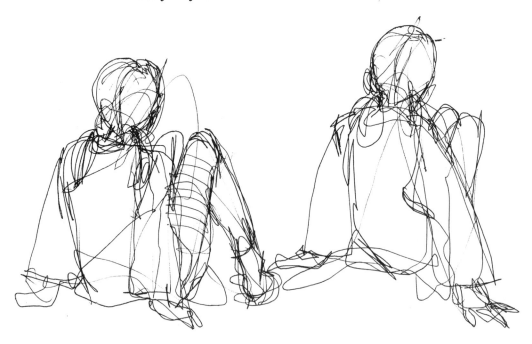

Learn to enjoy using a sketchbook

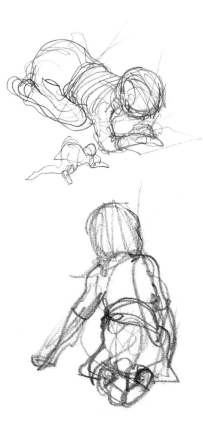

Invariably, I find that students erase a line which they consider to be wrong, and then replace it with another. But how can they tell when a correction has been made, if they cannot compare it with the original line? They might be drawing exactly over the first line. It is very useful to look back over your sketches to see the mistakes you have made, because that is the best way to learn. After all, there is always another page in the sketchbook, so simply start again. It is not like ruining a painting on which you have spent months. The important thing is to learn to enjoy using a sketchbook. Be as free and as uninhibited as possible and you will find that you have some vivid and lively sketches.

Sketching is all about learning to see and observe. Learn to look! We don't use our eyes as much as we should and, consequently, we miss a great deal. Apparently, few people look above their own eye-level when walking along! Looking at something is not enough, you must really *study* what you want to sketch, and know what you are looking for. Whatever you select to sketch, whether it's a tree or a person, the emphasis must be on that object. The surroundings are secondary. What you leave out of a sketch can be as important as what you put in, so use your main subject to lend scale and position to the other features.

Each object has its own value, and you must have the self-confidence to interpret the scene in the way it appeals to you. For example, if it is the shape of an arch in a bridge that attracts you, don't be afraid to emphasize that more than another feature, which could be considered of equal importance. In other words, you are putting your personal stamp on the scene in front of you.

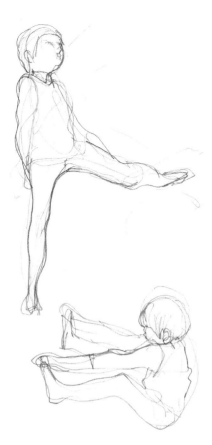

You cannot draw every detail of what's before you – things are too complex for that – so analyse the scene and simplify it. Half-close your eyes and reduce everything to basic shapes and outlines. Eventually you can add a certain amount of shading or detail, but you will be surprised to see how effective simple shapes can be in a drawing. The same principles apply when you are sketching figures. Look first for the basic shape, and try to see it as a silhouette. Then look for movement or action, and lastly, if you have time – the details.

There are two exercises that you can do that help to simplify the shape of the figure and also help you to memorise it. Firstly, ask someone you know either to stand, or sit still for a few minutes while you make an outline drawing round the figure. You can start the drawing wherever you choose – the ear, nose, chin, waist, knee or foot. Draw carefully and continuously all round the figure. With practice you will be surprised how effective these contour drawings can be. Eventually you can add a few more essential lines to indicate, say, the neckline, or the waist, and within the head shape you can roughly sketch in the features and the hairline.

The second exercise is to test your observation and memory. Again, ask a friend to stand in a particular pose for a few minutes while you study their figure as carefully as you can. When you have absorbed all the information you need about the pose, ask the friend

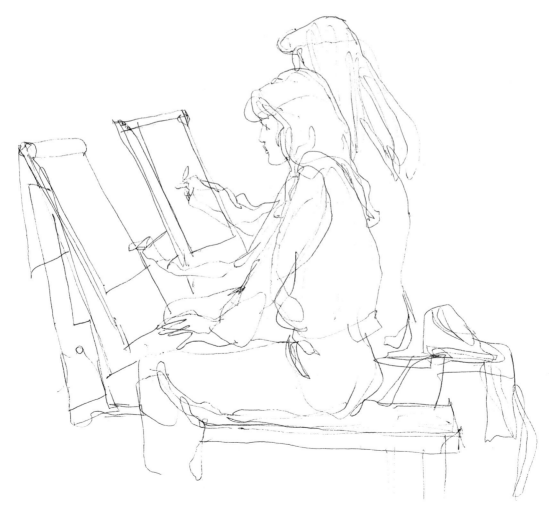

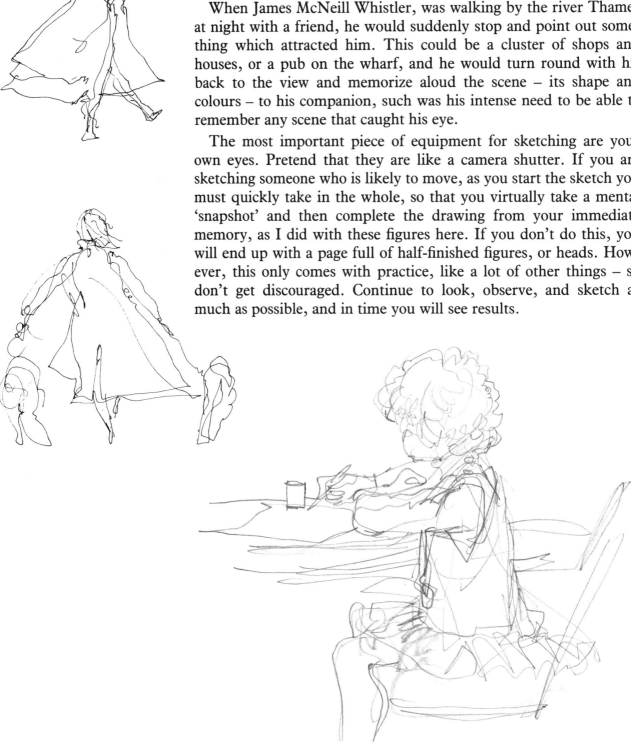

to move right away, and then start to sketch the figure that was before you from memory. When you have completed the sketch ask the friend to return and take up exactly the same pose again, so that you can see how you have done.

After doing this several times you will not only improve, but, more importantly, you will begin to learn to concentrate on the essentials in a limited time. The same exercise can, of course, be carried out with any still-life object, like a plant, some flowers, or an arrangement of household things.

When James McNeill Whistler, was walking by the river Thames at night with a friend, he would suddenly stop and point out something which attracted him. This could be a cluster of shops and houses, or a pub on the wharf, and he would turn round with his back to the view and memorize aloud the scene – its shape and colours – to his companion, such was his intense need to be able to remember any scene that caught his eye.

The most important piece of equipment for sketching are your own eyes. Pretend that they are like a camera shutter. If you are sketching someone who is likely to move, as you start the sketch you must quickly take in the whole, so that you virtually take a mental 'snapshot' and then complete the drawing from your immediate memory, as I did with these figures here. If you don't do this, you will end up with a page full of half-finished figures, or heads. However, this only comes with practice, like a lot of other things – so don't get discouraged. Continue to look, observe, and sketch as much as possible, and in time you will see results.

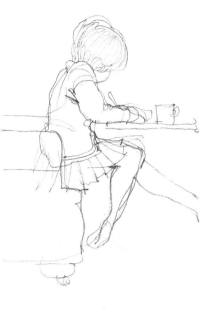

This method of sketching the whole figure very quickly is particularly good when children are your subject. As you know, children move continually, so you must again use the 'camera' technique and take a mental snapshot of the image, thus enabling you to continue the sketch when the child moves into a different pose. I find that it is best to study the child when it is absorbed in some peaceful occupation, like reading, drawing, or watching television.

Parents have an excellent opportunity to sketch small children if they are with them all day. Even if they don't have time to actually make sketches at the time, parents are constantly watching the children and observing all their actions. Children get into some quite extraordinarily contorted positions, which make you think that they must be made of rubber! I find it helpful to have the odd small sketchbook and pencil to hand in various places about the house, so that you can seize every opportunity for sketching when the moment arises. One of the best places to sketch children is near the television set, as watching television is one of the few occupations where they keep relatively still for fairly long periods of time.

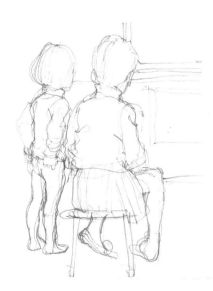

The proportions of children's bodies are quite different to those of adults. Their heads are large in comparison with their bodies, and younger children especially have tiny necks, narrow shoulders with waists hardly apparent, whereas their tummies are inclined to stick out! The positions children adopt are naturally fluid and supple, and only exceptionally fit adults, or dancers, can achieve them.

For those people without children, they can easily be observed and sketched at any outdoor playground, park, or fair, although most people know someone who has children. Why not offer to babysit and have your models on hand? Offer to collect children from school and you will observe many different shapes and sizes as they come out into the playground. Even if it is not possible to do the drawings 'on the spot', observe, look and remember, and when you get back home jot down quickly those figures you can recall.

Draw freely with a continuous line

When you start to sketch, try to do what I call 'a calculated scribble'. Draw freely with a continuous line which embraces the whole figure, and gradually elaborate upon this groundwork so that you have at least indicated the entire figure, and only then should you get down to putting in the details more clearly. Do not 'stroke' the paper with your pencil – be bold and try to draw in one long uninterrupted line, continuing fearlessly until you have completed the figure. You will get some funny-looking scribbles to start with, but in time and with practice, your scribbles will become more defined and more accurate. Then as you progress you can do fewer lines and get better sketches.

Do not try to start off with a detailed sketch of the child's face and features, for example, and then carry on drawing slowly and carefully down the body. If you do, by the time you have completed the nose or eyes, the child will have moved. This is where children watching television are an ideal starting point, as they are sitting still and this

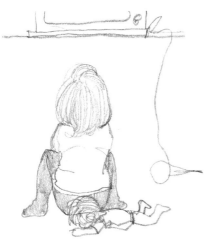

will help to give you confidence. You tend to get lots of side views and profiles this way, but you find that as the children become accustomed to this new occupation of yours, you can move round in front of them and get some full faces, when they are engrossed in something on the screen. Although there is bound to be one who wants to do a sketch on your pad! Remember, children grow up much more quickly than you think, and before you realise it, they are young adults. So do as many sketches as you can of them while they are young.

Naturally, sketching adults is easier than sketching children, and it is probably best to start with your own family, who, it is hoped, will be co-operative and interested. They can be positioned where you want them and relied upon to keep the same pose for several minutes. It is often an ideal opportunity to approach members of your own family and friends when they are sitting comfortably reading a newspaper, watching television, or performing some other domestic activity, and ask them to let you sketch them then. This will give you confidence and experience in recording events and scenes from everyday life. But, don't take too long over your sketching, or they, too, will get bored, and start to move, or fidget.

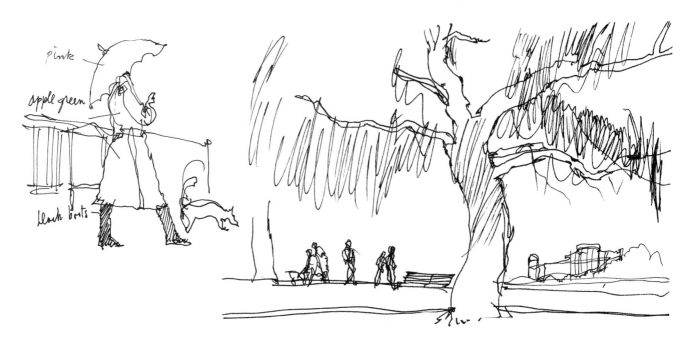

Sketching people in public parks

Public parks, too, are excellent places in which to start sketching. You can just sit on a bench and watch the world go by, and there is so much to see and to draw as you will see from my sketching here. If you are shy, or a little apprehensive, simply put your sketchbook in a folded newspaper or magazine, and pretend you are reading! Only a short distance away there might be a family having a picnic, playing ball, or simply sitting on the grass, and they will probably not notice you sketching them. Just sit and observe and try to jot down the scene around you. If you see a particular figure that strikes you as interesting, always make a quick sketch on the spot.

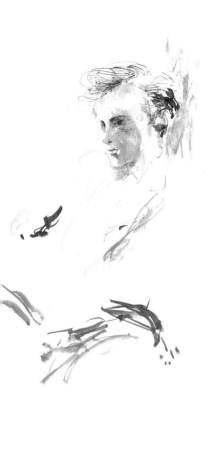

Although it was wartime, perhaps the happiest and most carefree drawings I ever did were those when I was an art student at Brighton Art School in 1940. Great emphasis was put on figure drawing in those days and a couple of students and I used to cycle to a place in the Sussex countryside, near Cuckfield, and sketch each other in the woods near a stream. Since those formative years, I have always been more attracted to drawing the human figure, rather than landscapes or buildings.

During the war, when I was in the R.A.F., I had a golden opportunity to make sketches of people, and I sometimes regret that I did not do more. Servicemen were very bored for much of the time and were quite pleased if someone wanted to sketch them. Often they were not aware that I was drawing them when they were lying on their beds, or in some other relaxed position, as in the sketch here.

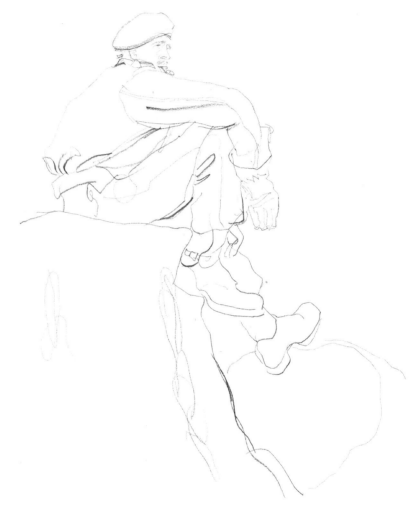

There were also various portrait requests from servicemen to send to their girlfriends, or family. I can remember one chap that I sketched – afterwards I found him surreptitiously rubbing out the moustache and redoing it, as he didn't consider that I had got it quite right!

Most service units of any size had their 'resident artist', many of them cartoonists, and I was often called upon to do rather odd 'commissioned' drawings, such as painting Mae West on the side of

an American bomber! Or helping an officer-artist paint murals on the walls of what used to be a holiday camp on the bleak Yorkshire coast.

I was actually stationed in Germany from April 1945 to December 1946 and the sight of this bombed and devastated country had a profound effect on me, so that I felt compelled to record my impressions of these horrific scenes. Anyone visiting Germany today would never have believed how ruined the towns and cities were. Many people were starving and in Cologne the only building standing intact was the famous cathedral. There are several of my wartime sketches later in the book.

The most sorrowful person I drew at the time was this 17-year-old German youth (below) who had only served six months in the

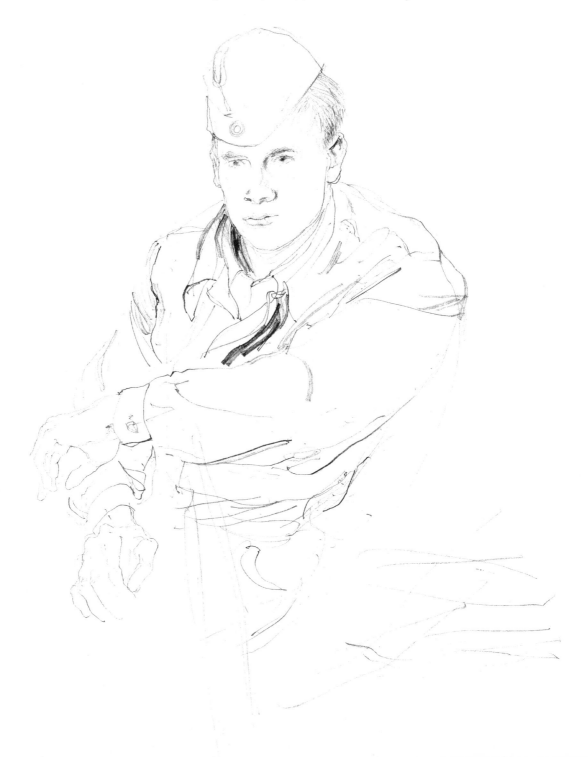

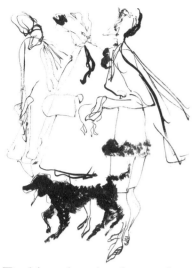

Fashion drawing has to be done quickly

'Kreigsmarine' (German Navy). He was in a working party of German prisoners-of-war, working on a deserted Luftwaffe airfield near Münster. He approached me and said that he was only seventeen and that he was hungry. I made several drawings of him in return for a bar of chocolate, with which he was very pleased.

While I was stationed in Germany we were given the occasional 48-hour leave in Brussels, and the contrast with Germany was quite startling. The people in the Belgian capital appeared to be living almost luxuriously and there was so much light, life and pleasurable entertainment everywhere. The cafés were full and there was a thriving black market. As you can see from my sketches here the women were dressed in the rather exaggerated fashions of the time – short skirts, high heels, painted faces, and often accompanied by poodles.

Curiously enough, when I was demobbed from the R.A.F., it was one of my Brussels sketches that caught the eye of an agent who suggested that I should specialize in fashion drawing. I got a job on *Vogue* magazine where I had to sketch garments in the Paris collections to be featured later in the magazine. These sketches had to be

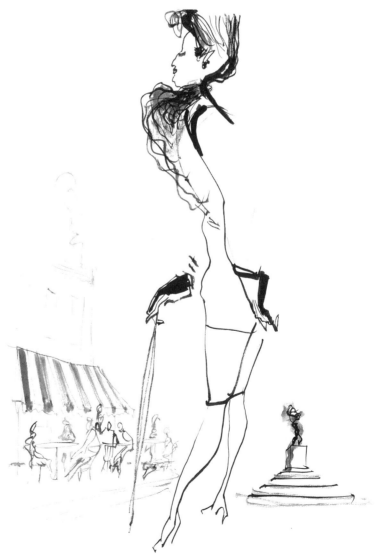

done very hurriedly, often in the evening, as the clothes were in the fashion shows during the day. Sometimes, a particular garment was taken away to show to a potential buyer in the middle of one's sketch. It was a hectic, frenzied, but very exciting time, in which it was imperative to be able to make really rapid sketches. There was often only time to scribble down detail notes of the garment, i.e. material, colour, and design features. The main requisite for a fashion illustrator is, therefore, to be able to sketch very quickly, and this is, of course, extremely good training for sketching other things too.

After working for Vogue and then for Simpson of Piccadilly as fashion illustrator, I gradually started to do more general illustration, which I found more interesting. One of my best assignments was to draw people in the Tate and National Portrait Galleries (see below). It was both interesting and comparatively easy, because you can position yourself at a vantage point in an art gallery and no-one takes any notice of you, as they assume that you are sketching a particular piece of sculpture, or a painting, when in fact you are drawing them! I would certainly recommend art galleries and museums for drawing people because you will find an interesting mix of people there and you can sketch undisturbed, and often inconspicuously.

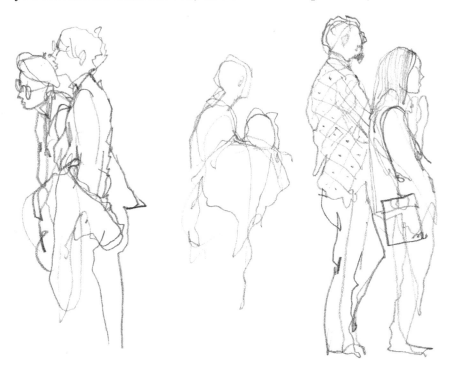

I have been teaching in the fashion department at London's St. Martin's School of Art for many years now. I am concerned mainly with teaching students basic fashion drawing. Potential fashion designers rely entirely on their design drawings both to get a job, and to sell their designs. It is essential for them to learn to be able to make quick, stylish drawings of the complete figure and to be able to remember details.

When interviewing students who want to become fashion designers, I know that the first, and possibly the most important

thing that they are asked to show is their sketchbooks. The varied contents of well-filled sketchbooks give the interviewer the best insight into students' artistic potential, sense of observation, and personal taste.

Timed poses are good drawing exercises

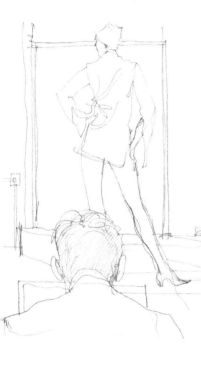

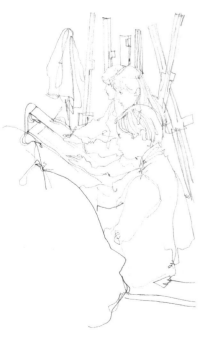

I have found that it is best to force students in at the deep end, as it were, with drawing. I often give them short, timed poses of 2–5 minutes (as these two sketches here), in which to draw the whole figure, and I insist on the whole figure, no matter how badly it is drawn. It is no use making a nice, careful drawing of the head in ten minutes, when you have been asked to draw a standing figure, and that, as fashion design students, is their only concern. Having to do timed drawings is the best exercise for learning to sketch quickly.

It is well known that Anguste Rodin, the French sculptor, used to draw models as they moved casually about his studio. He would draw continuously, dropping the drawings one by one on to the floor while he kept his eyes glued to the moving models. 'The moment I drop my eyes – the flow stops ...' he used to say. He was the greatest exponent of rapid figure drawing and influenced such artists as Matisse and Munch. Sometimes Rodin would correct a line several times, but the lines were never erased. If a sketch did not come off, then another would be started, and in this way his sketches were always spontaneous and free.

Whistler, having spent most of his life producing large paintings, often life-sized, finished up in his last two decades doing very small watercolour and oil sketches, and many people think that these are some of his greatest works. Like Constable's sketches, these tiny pictures of Whistler's have been largely ignored by the art public.

The most interesting thing about the famous artists that I have mentioned in this book is that they all drew quite small – in fact, some of Turner's and Constable's sketches were really tiny! Turner's favourite-sized sketchbooks were $4\frac{1}{2} \times 7\frac{1}{4}$ in (115 × 184 mm), although he often worked smaller. The average-sized sketchbook that Constable used was about $3\frac{1}{8} \times 4\frac{1}{4}$ in (80 × 108 mm), while Whistler's oil and watercolour sketches were done on paper sized $5\frac{1}{2} \times 9\frac{1}{2}$ in (140 × 240 mm), and Rembrandt's sketchbooks were about $9 \times 5\frac{3}{4}$ in (225 × 145 mm).

All these artists worked very small, and I think you will find it easier too. Many people often want to do large, impressive sketches, but I find it best to start off small at first, until you become more proficient and confident. Also, by drawing too large you can often overstretch your medium. For instance, if you are using an ordinary biro pen, 9 in (230 mm) is about the maximum height, or width, of the page that should be used; after that you need a thicker fibre-tipped pen, or a fountain pen with a wider nib. I usually find that for general sketching in a small sketchbook of cartridge paper I use a B or 2B pencil, for landscapes something softer up to 6B, and for detailed drawings of buildings, something harder like an HB is best. Perhaps B or 2B are the most versatile pencils to use.

Use only one side of the page

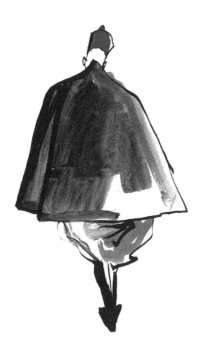

If you are using pencil in your sketchbook it is better to use only one side of the page, otherwise the sketches are inclined to smudge against each other. The other disadvantage, if you use both sides of the paper, is that if you particularly like a sketch and wish to take it out of the book, there is another sketch on the back! I prefer spiral-bound sketchbooks as they fold right back and you can easily extract any one page. On the other hand, the ordinary perfect-bound sketchbooks are cheaper and you can sketch right across two pages, which is very useful for landscapes. Remember, that in a sketchbook there is always another page to draw on, so you can afford to make mistakes – it's not like drawing on expensive sheets of paper, or canvas, which can be quite intimidating.

While compiling this material for the publisher I unearthed all my sketchbooks stretching back many years to art school days. It was interesting to discover that in these I had visual records of most of the important events in my life. I have numerous sketches of my children growing up, from the time they were babies. I suddenly became aware that my sketchbooks comprised a fascinating pictorial diary of my life, far more vivid than any written diary could have been. Therefore, I cannot urge you enough to start recording and sketching your own life, and the events and people around you, so that you too can look back through your sketchbooks in later years, with pleasure and interest.

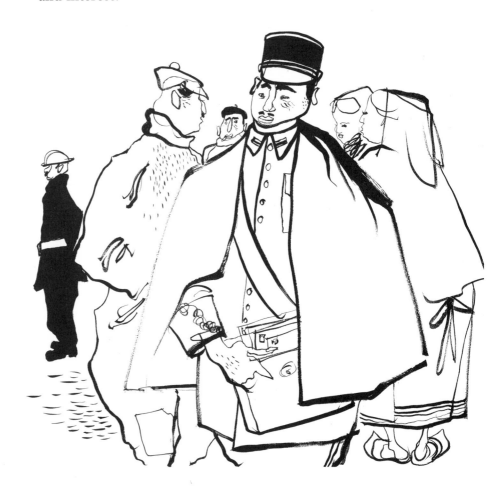

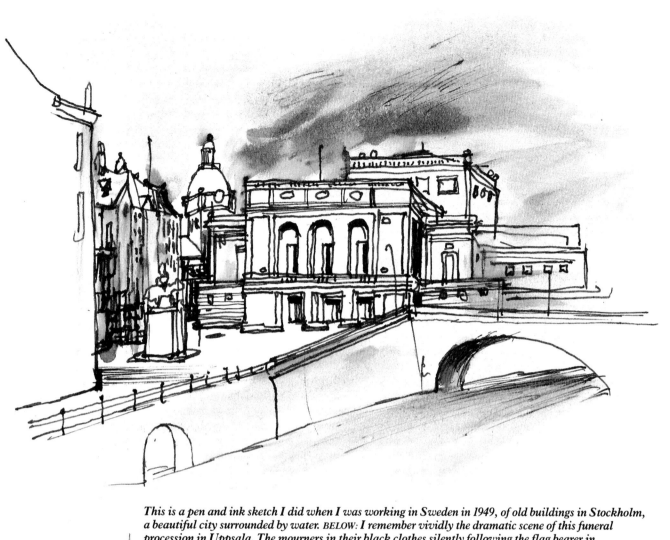

This is a pen and ink sketch I did when I was working in Sweden in 1949, of old buildings in Stockholm, a beautiful city surrounded by water. BELOW: I remember vividly the dramatic scene of this funeral procession in Uppsala. The mourners in their black clothes silently following the flag bearer in the falling snow, all silhouetted sharply against the grey background. I did this sketch in pencil and watercolour.

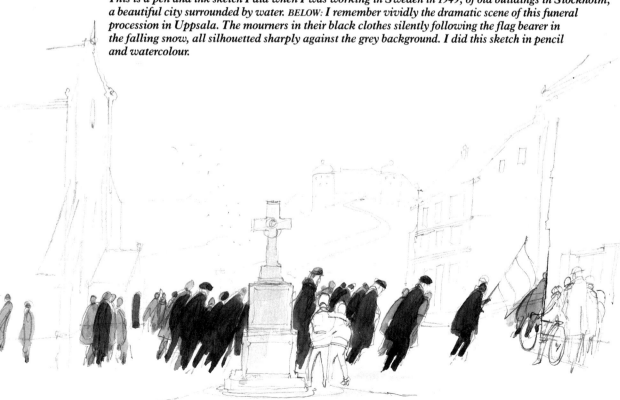

17

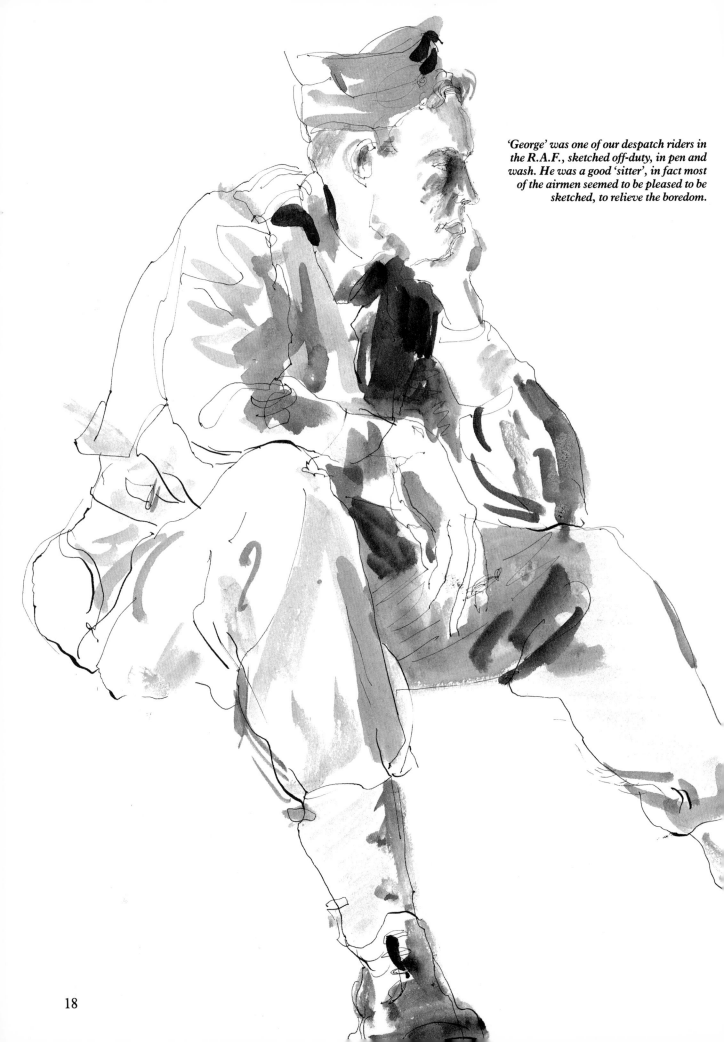

'George' was one of our despatch riders in the R.A.F., sketched off-duty, in pen and wash. He was a good 'sitter', in fact most of the airmen seemed to be pleased to be sketched, to relieve the boredom.

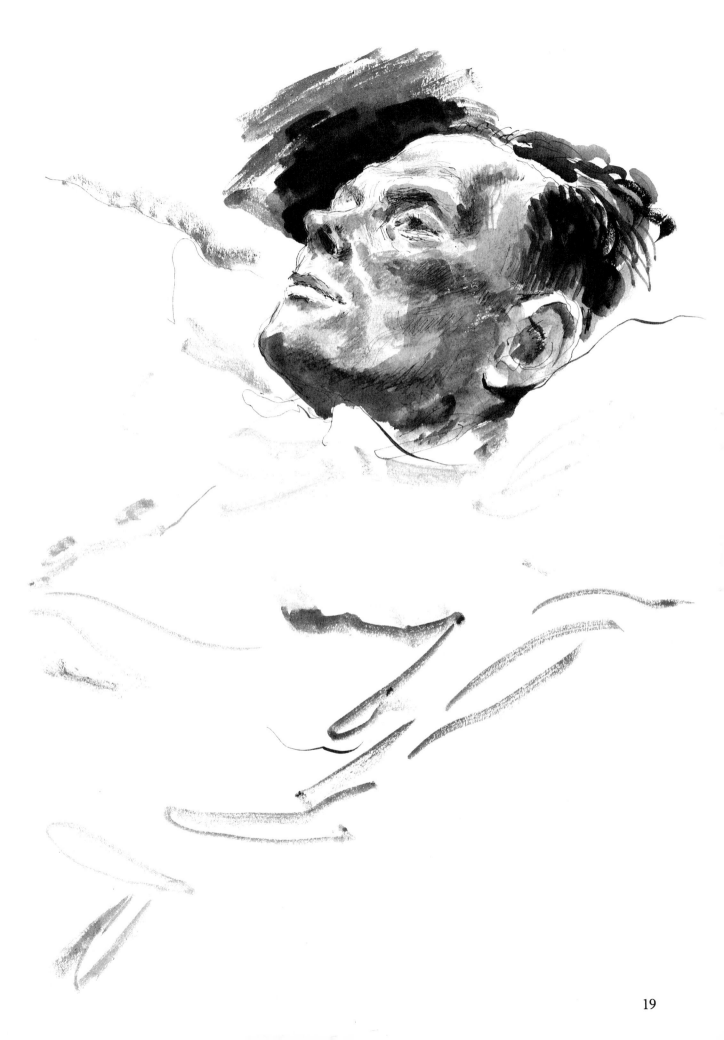

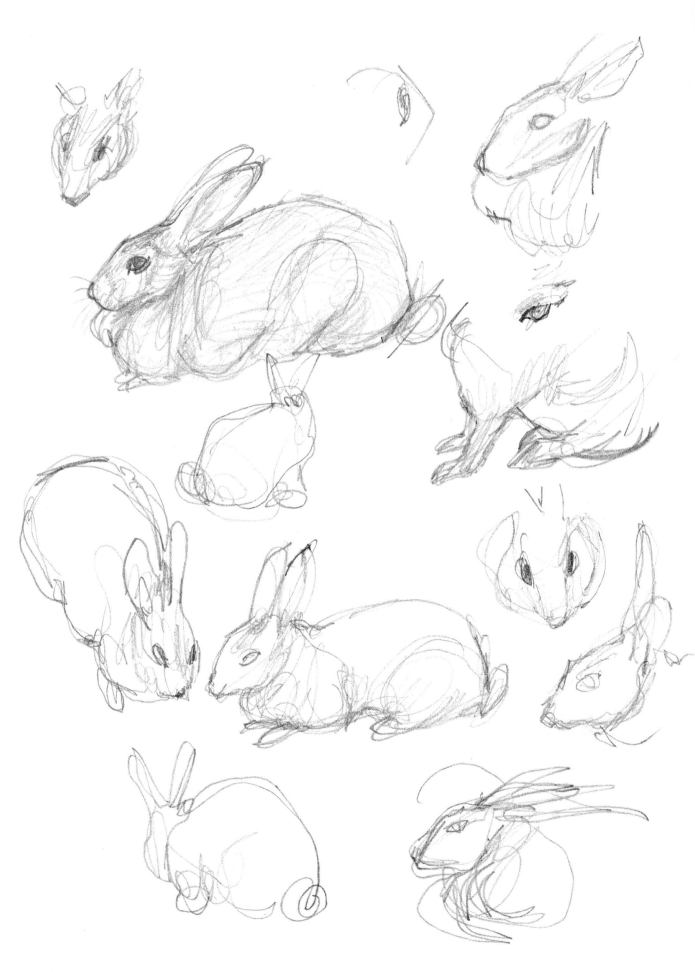

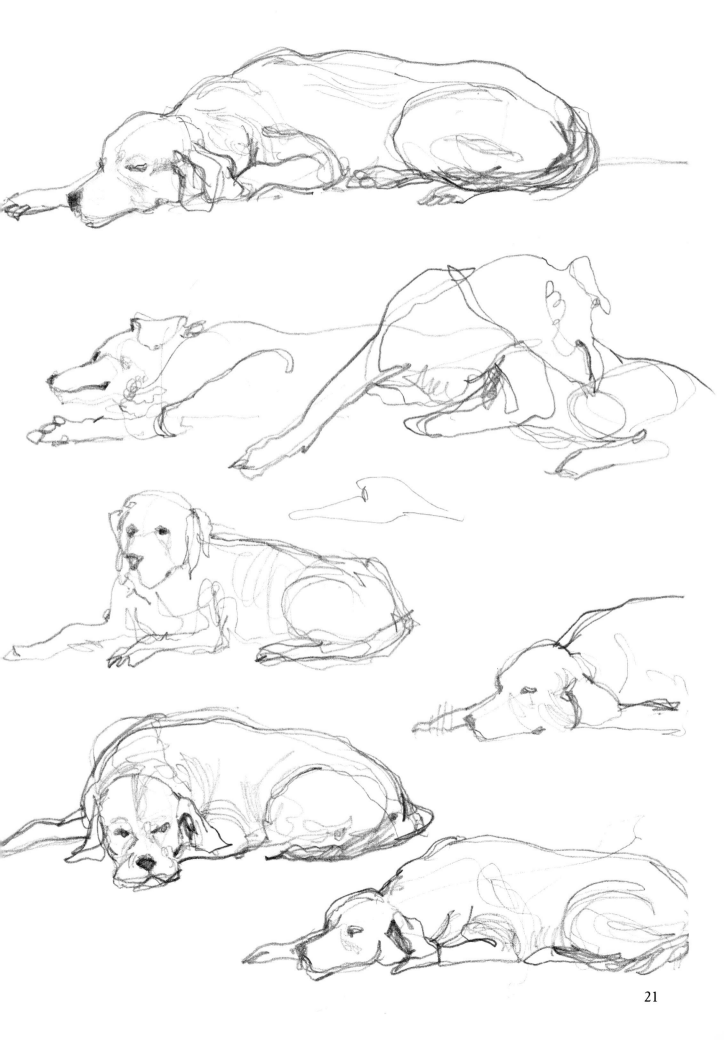

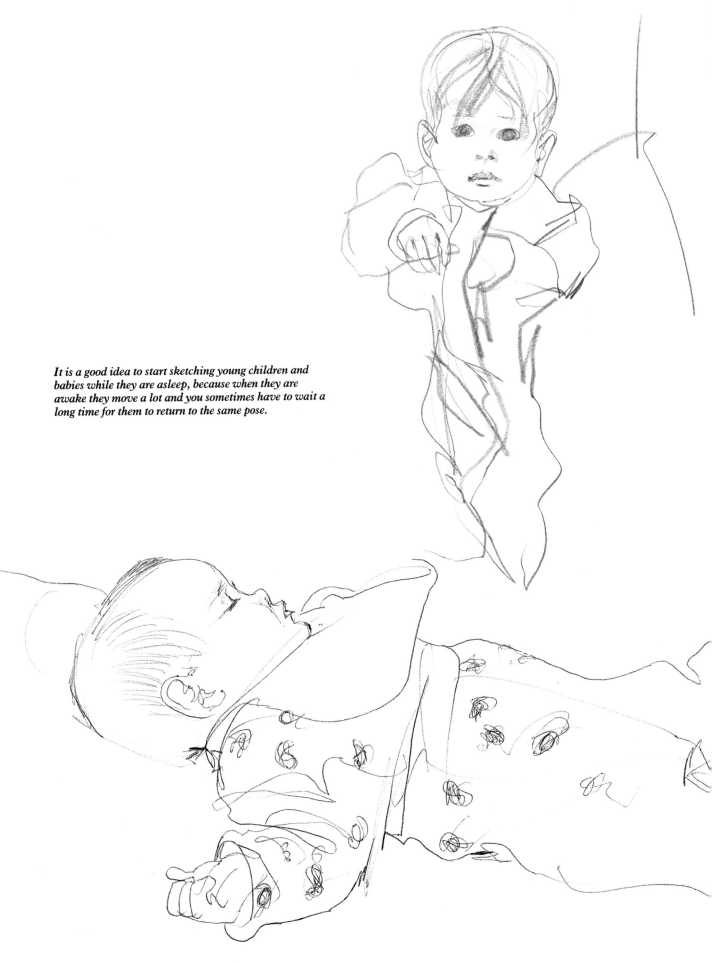

It is a good idea to start sketching young children and
babies while they are asleep, because when they are
awake they move a lot and you sometimes have to wait a
long time for them to return to the same pose.

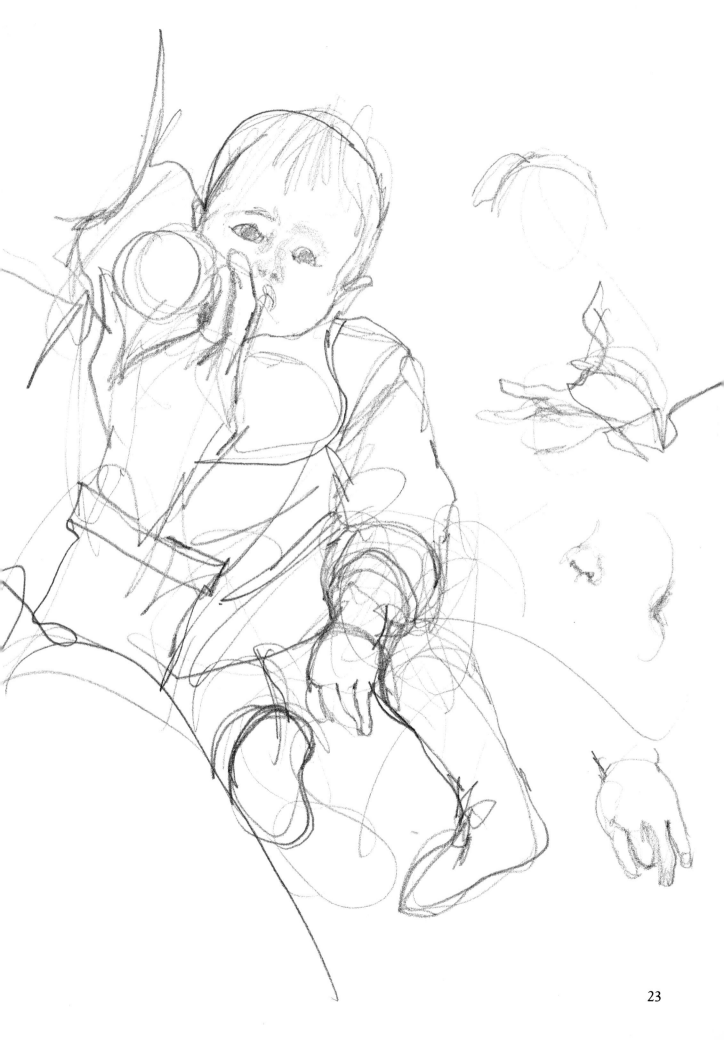

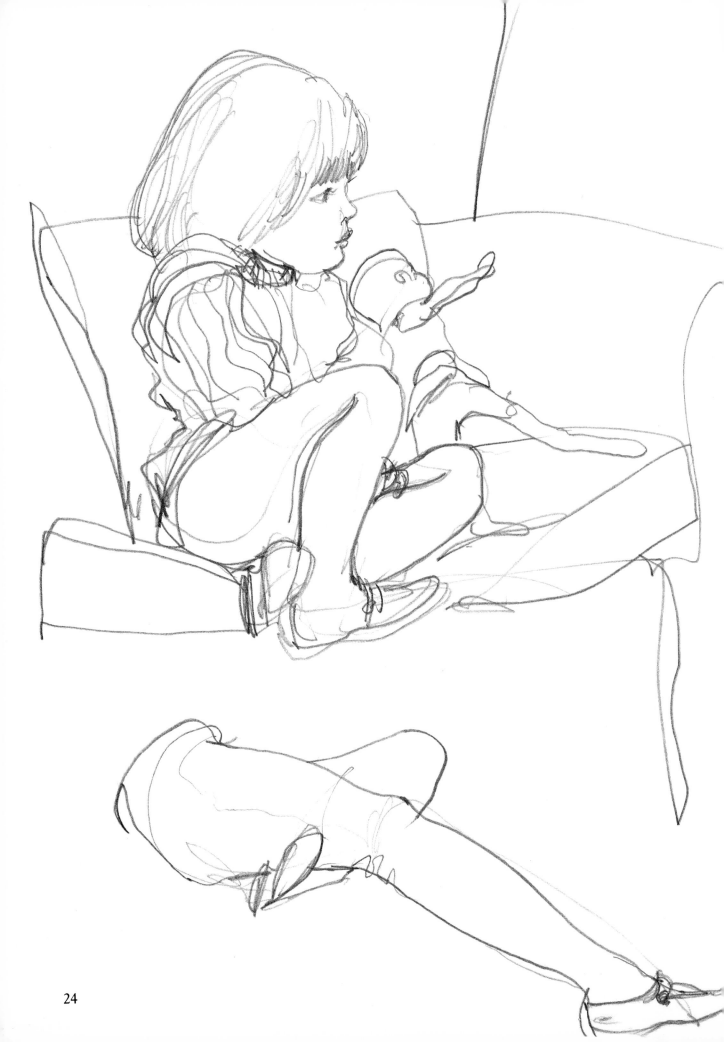

24

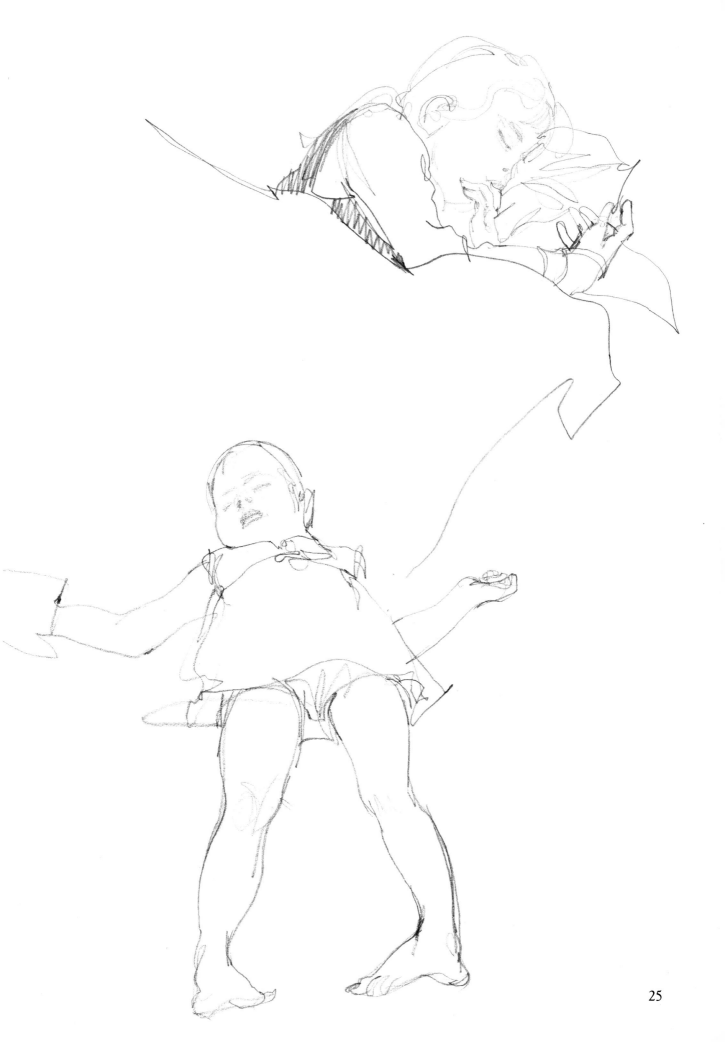

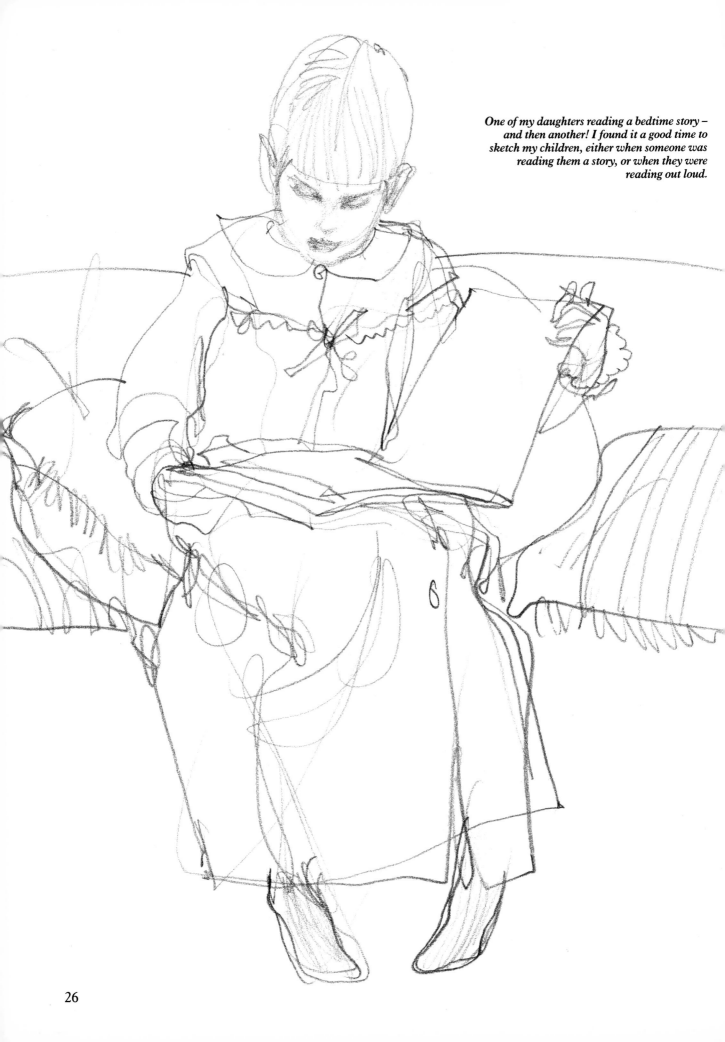

One of my daughters reading a bedtime story –
and then another! I found it a good time to
sketch my children, either when someone was
reading them a story, or when they were
reading out loud.

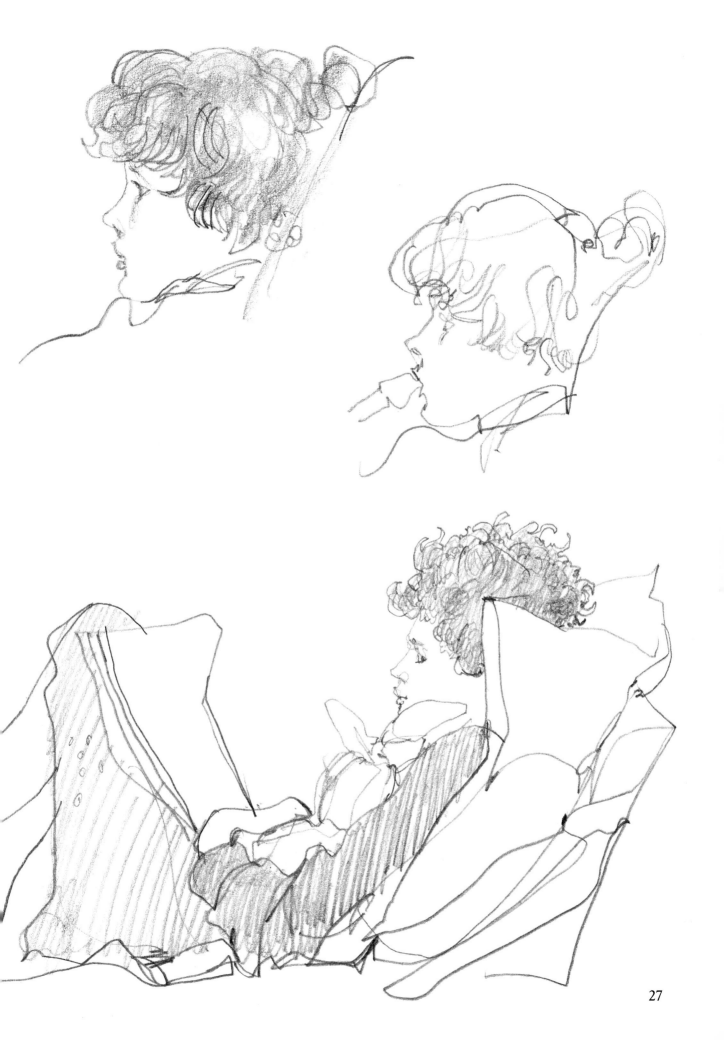

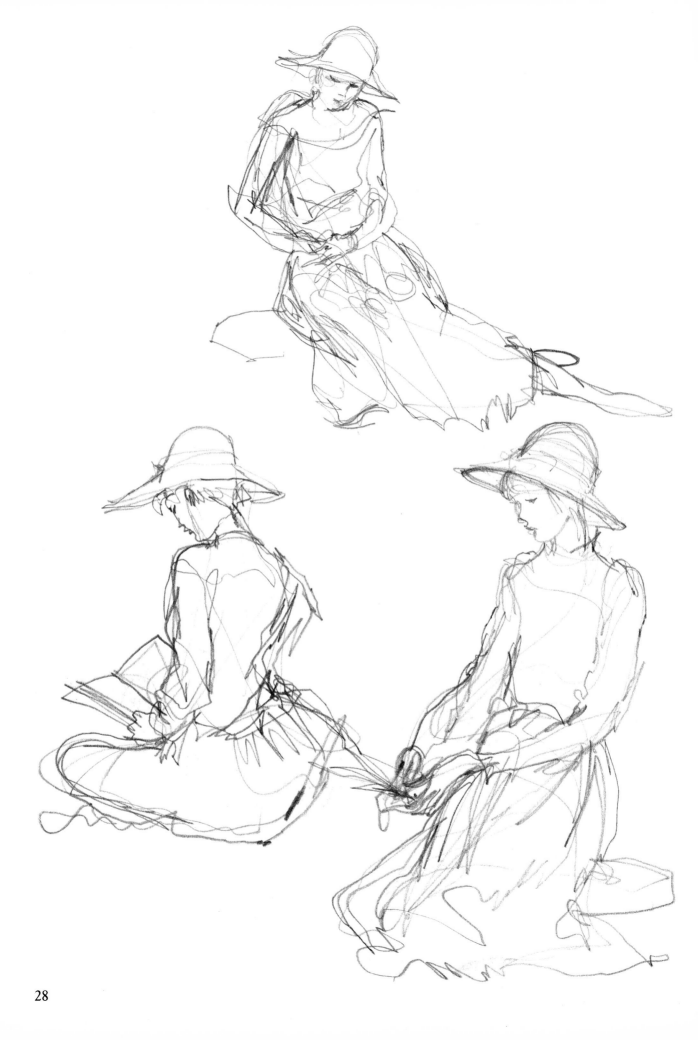

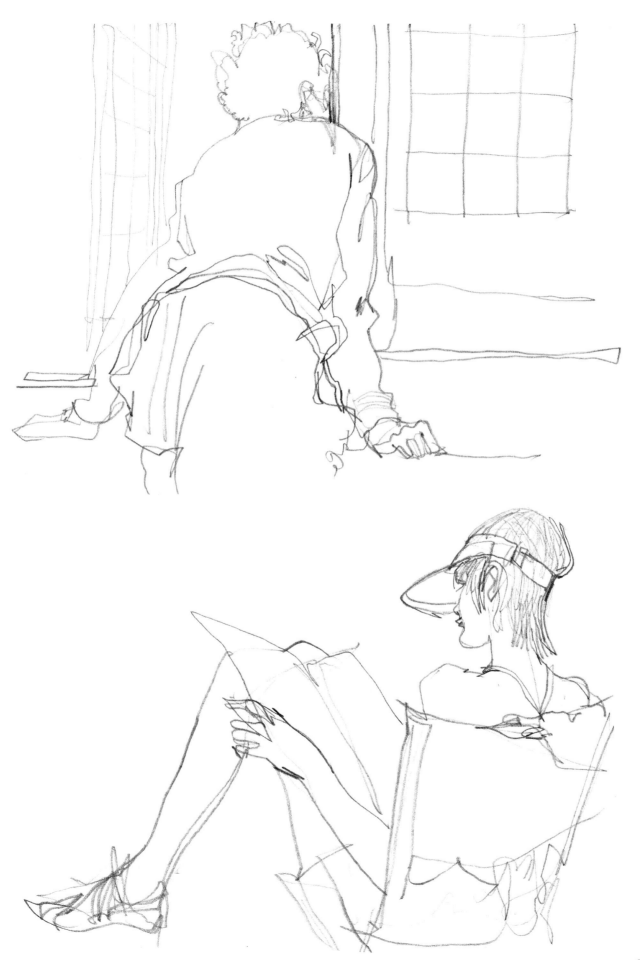

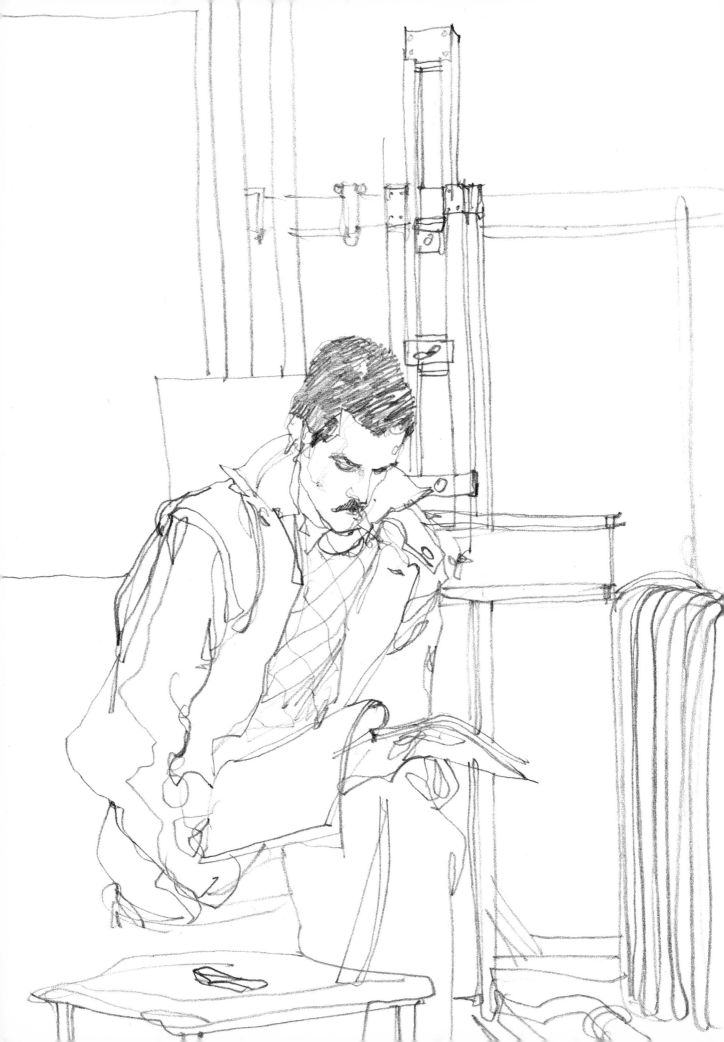

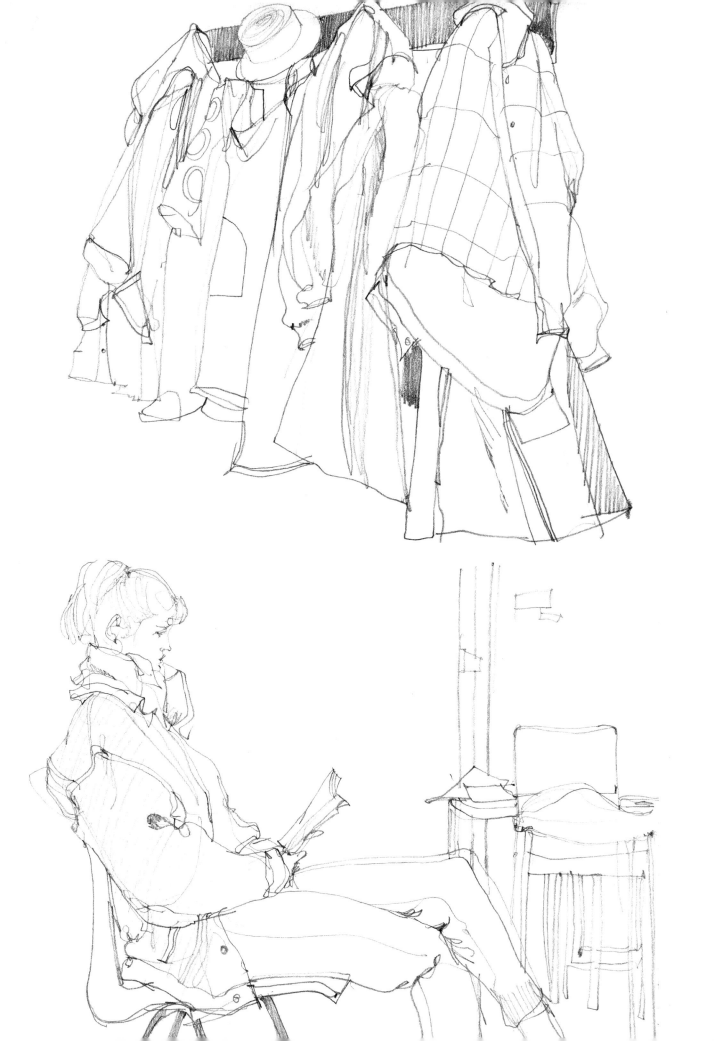

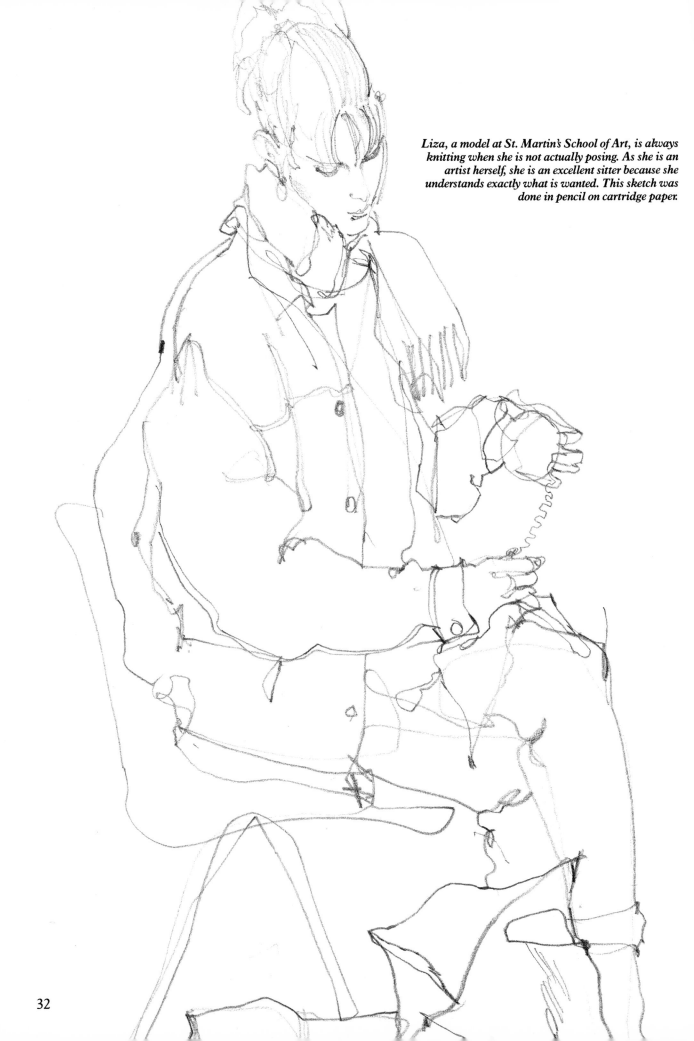

Liza, a model at St. Martin's School of Art, is always knitting when she is not actually posing. As she is an artist herself, she is an excellent sitter because she understands exactly what is wanted. This sketch was done in pencil on cartridge paper.

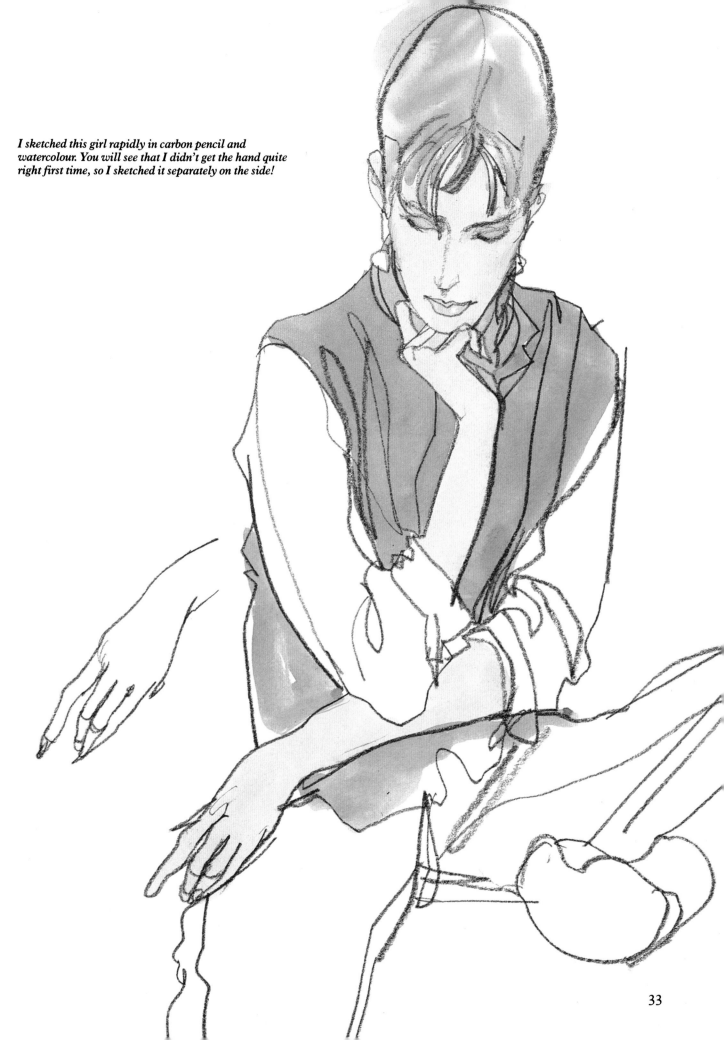

I sketched this girl rapidly in carbon pencil and watercolour. You will see that I didn't get the hand quite right first time, so I sketched it separately on the side!

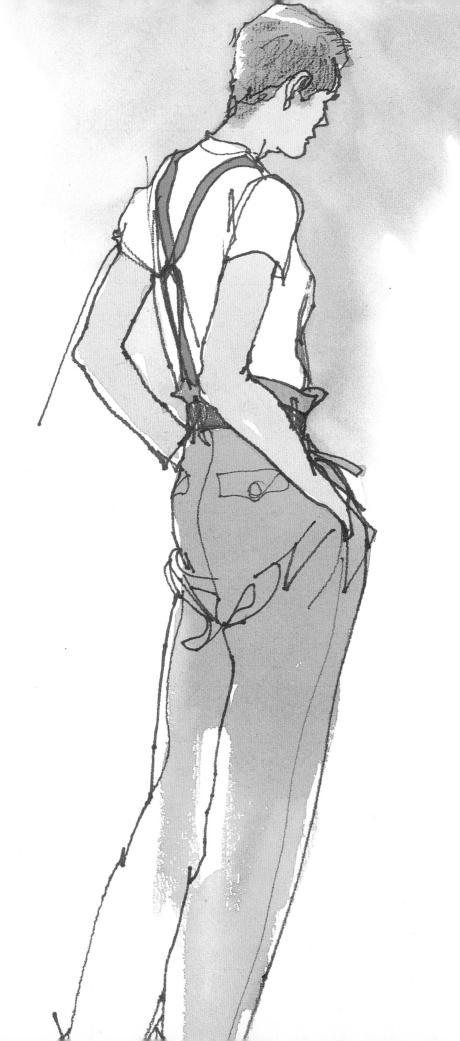

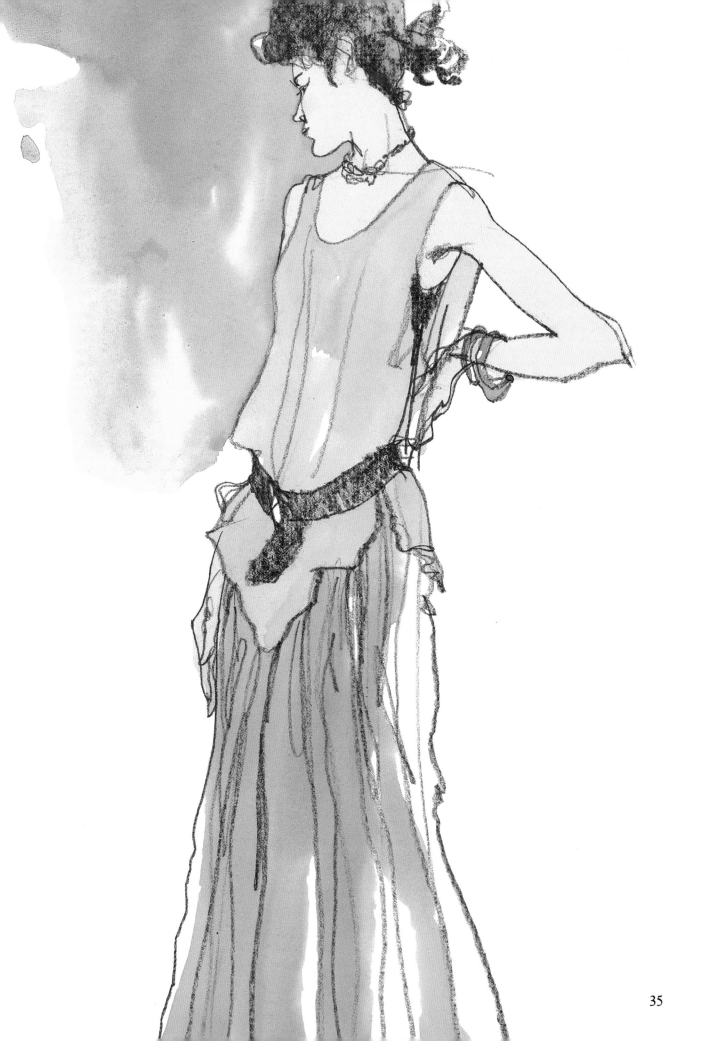

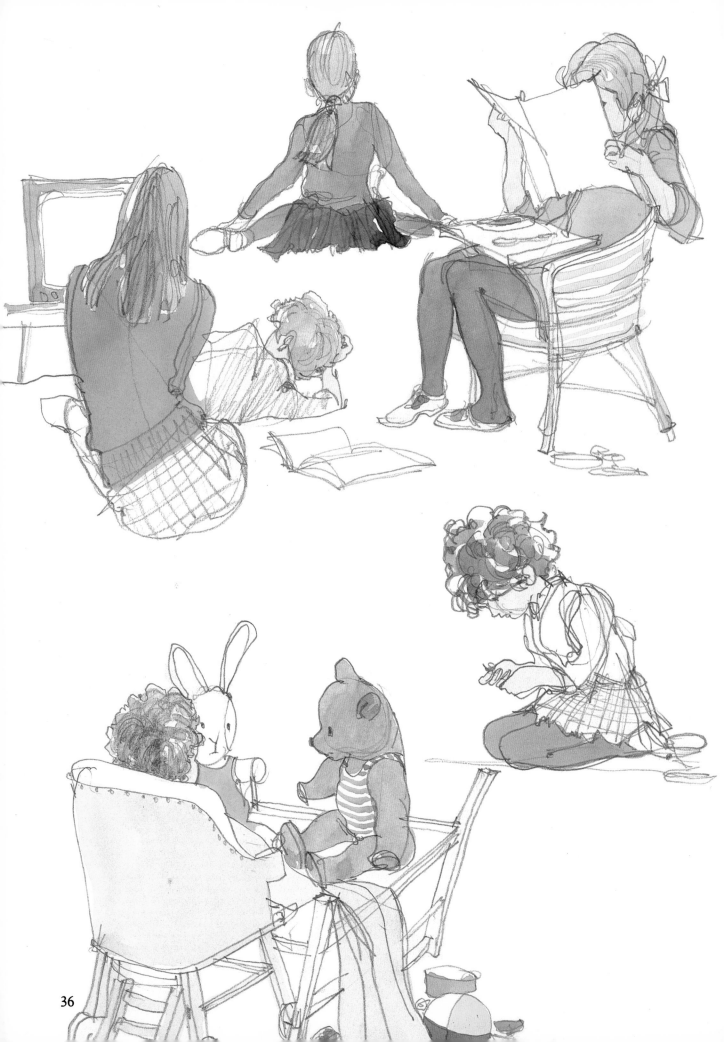

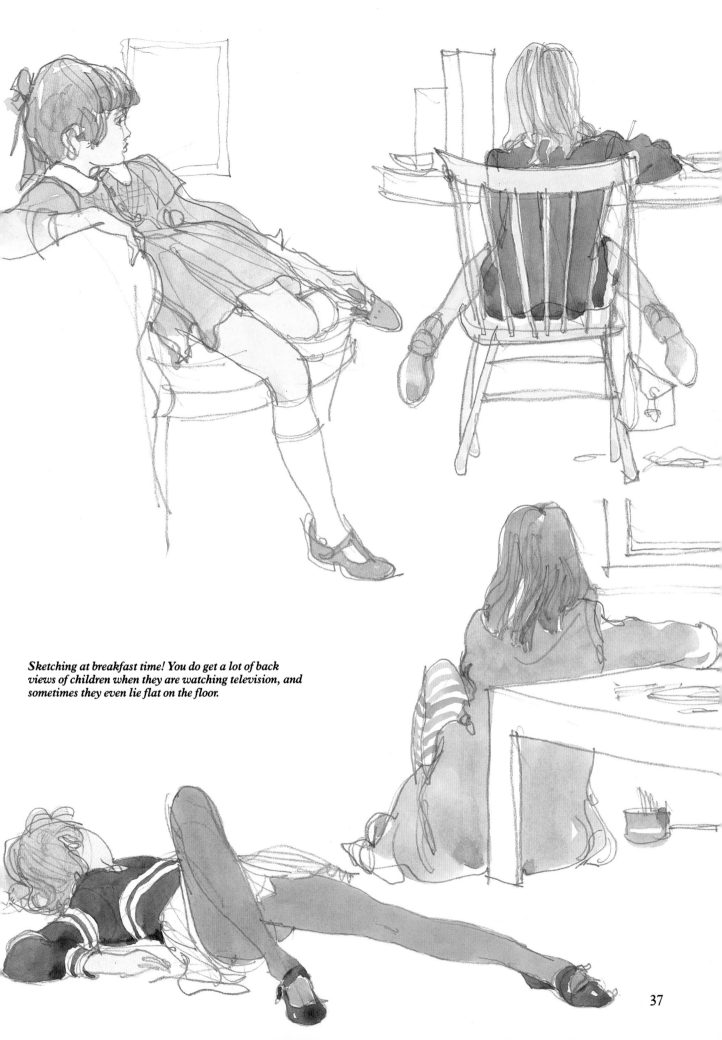

Sketching at breakfast time! You do get a lot of back views of children when they are watching television, and sometimes they even lie flat on the floor.

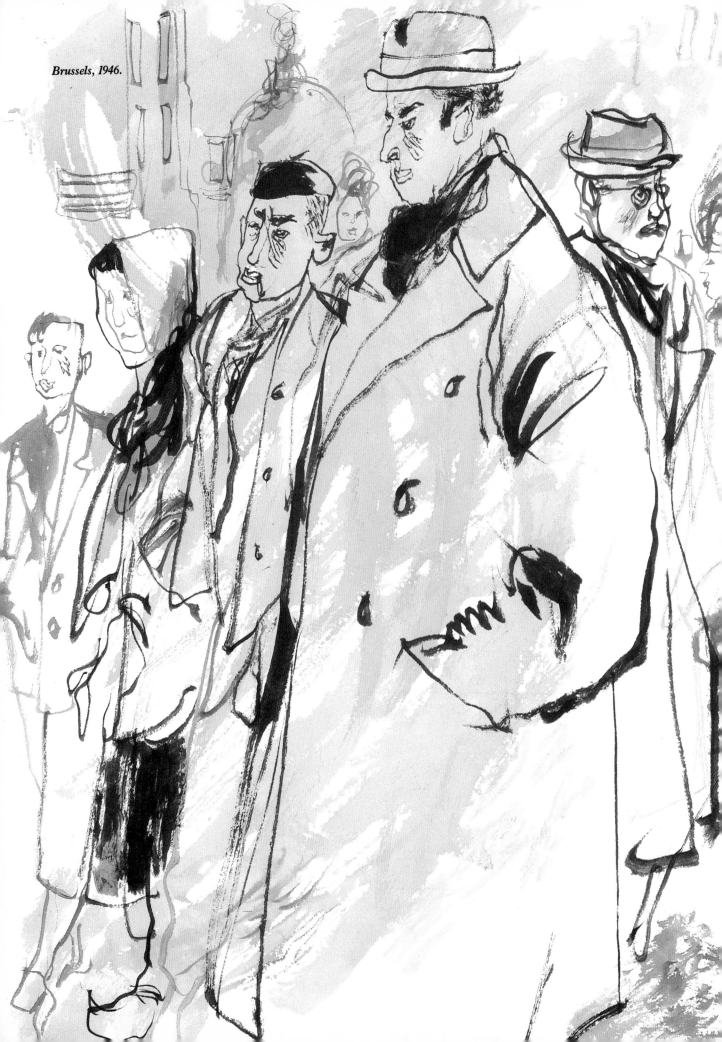

Brussels, 1946.

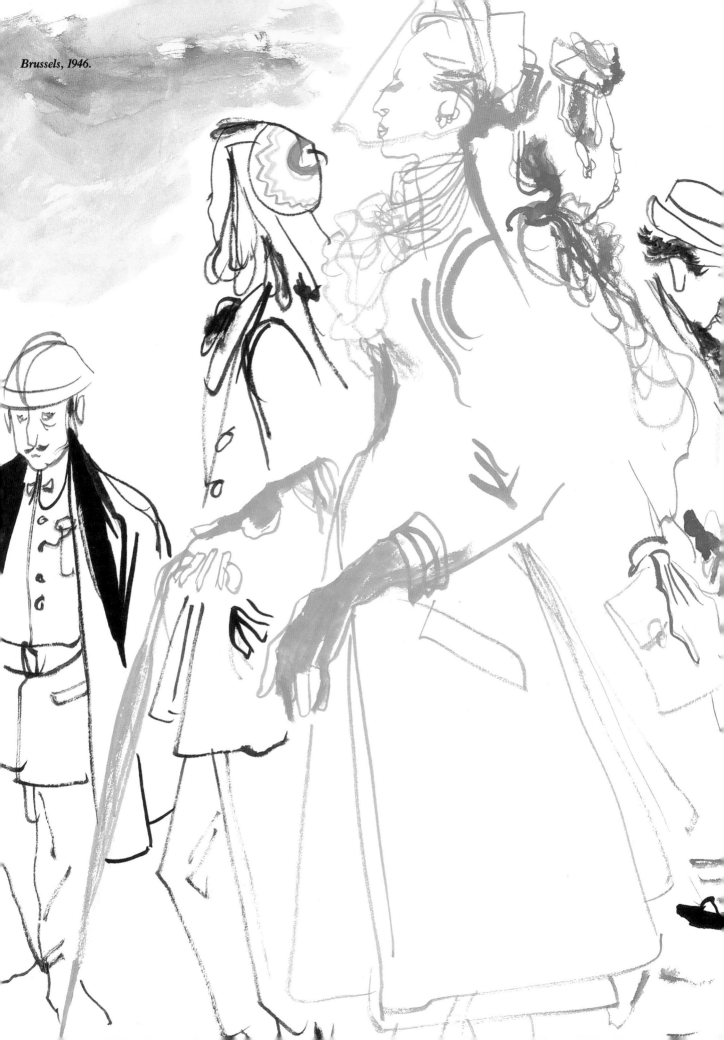

Brussels, 1946.

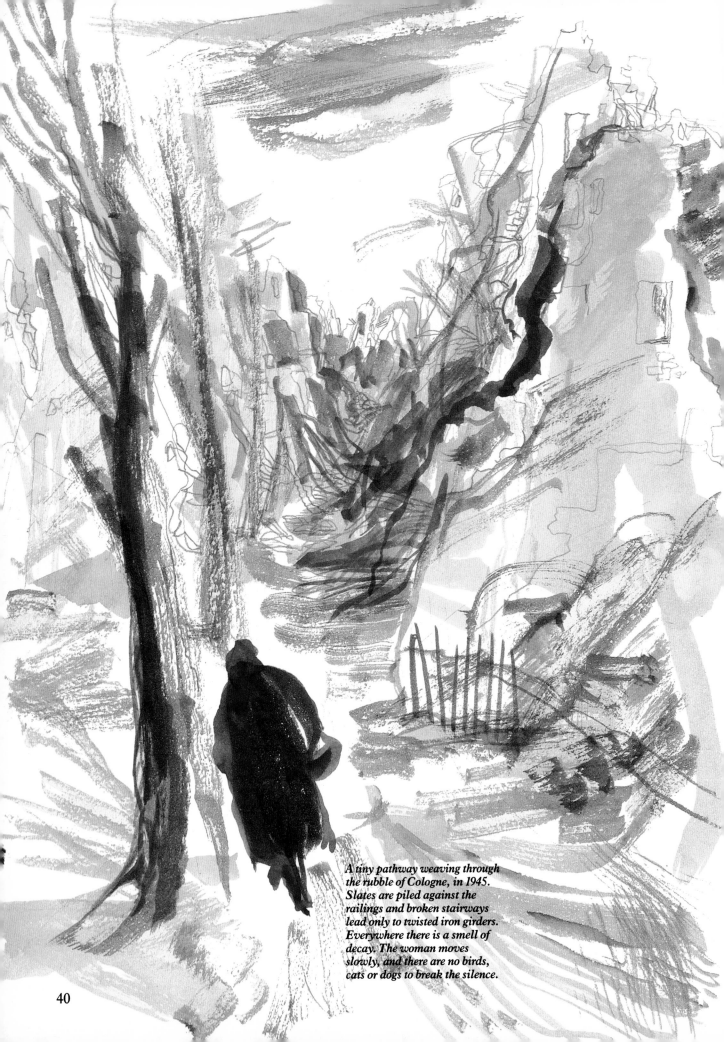

*A tiny pathway weaving through
the rubble of Cologne, in 1945.
Slates are piled against the
railings and broken stairways
lead only to twisted iron girders.
Everywhere there is a smell of
decay. The woman moves
slowly, and there are no birds,
cats or dogs to break the silence.*

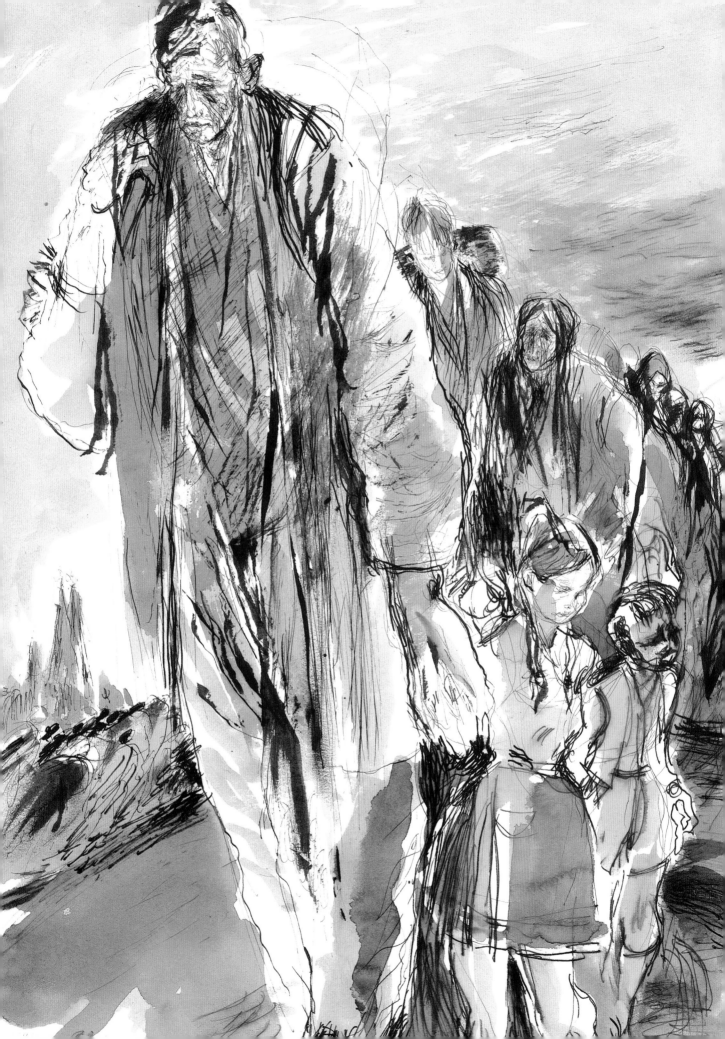

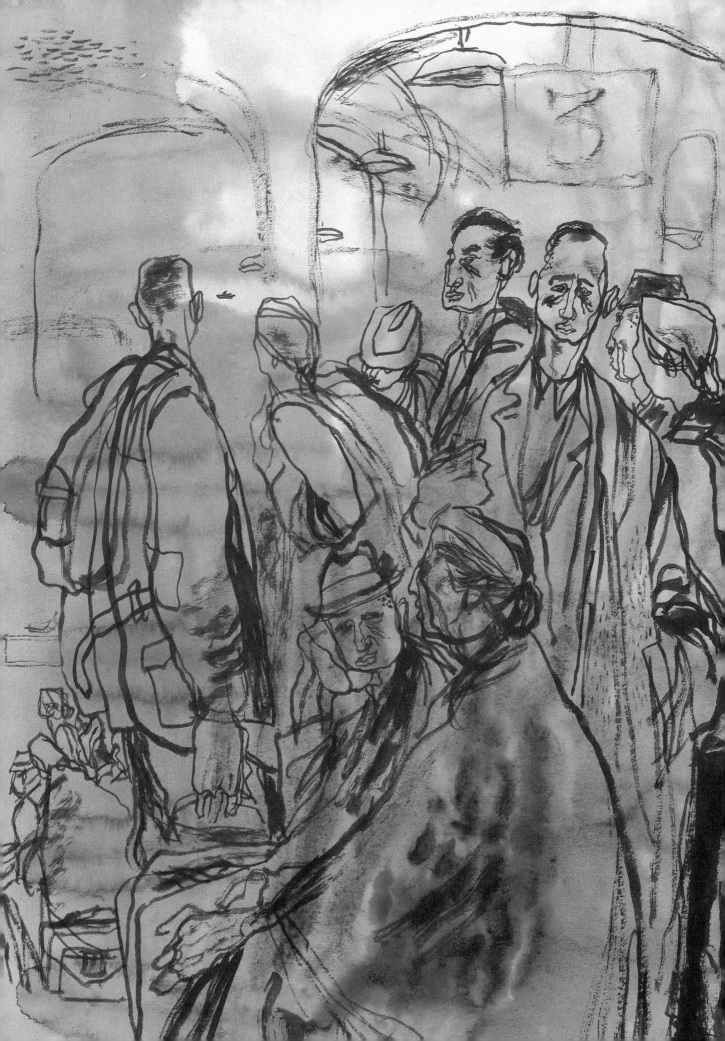

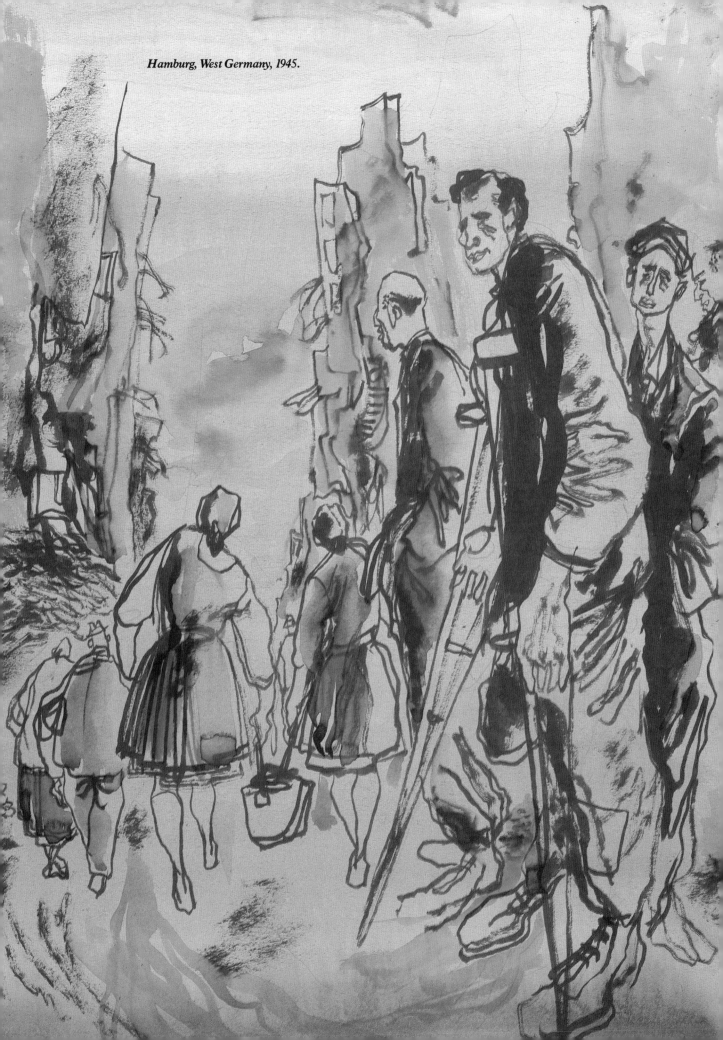

Hamburg, West Germany, 1945.

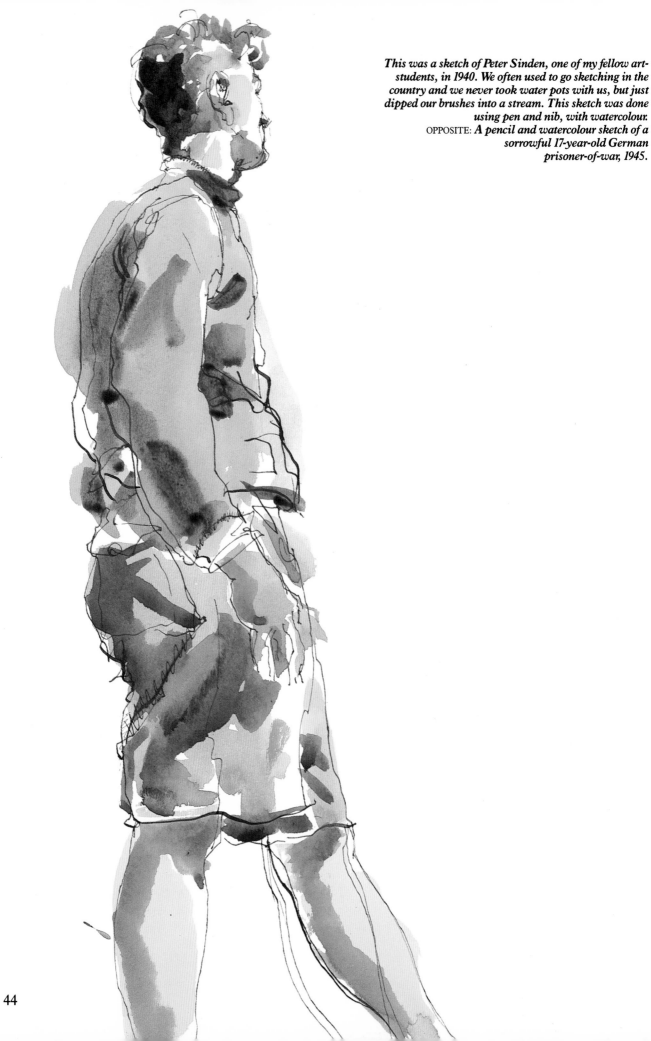

This was a sketch of Peter Sinden, one of my fellow art-students, in 1940. We often used to go sketching in the country and we never took water pots with us, but just dipped our brushes into a stream. This sketch was done using pen and nib, with watercolour.
OPPOSITE: A pencil and watercolour sketch of a sorrowful 17-year-old German prisoner-of-war, 1945.

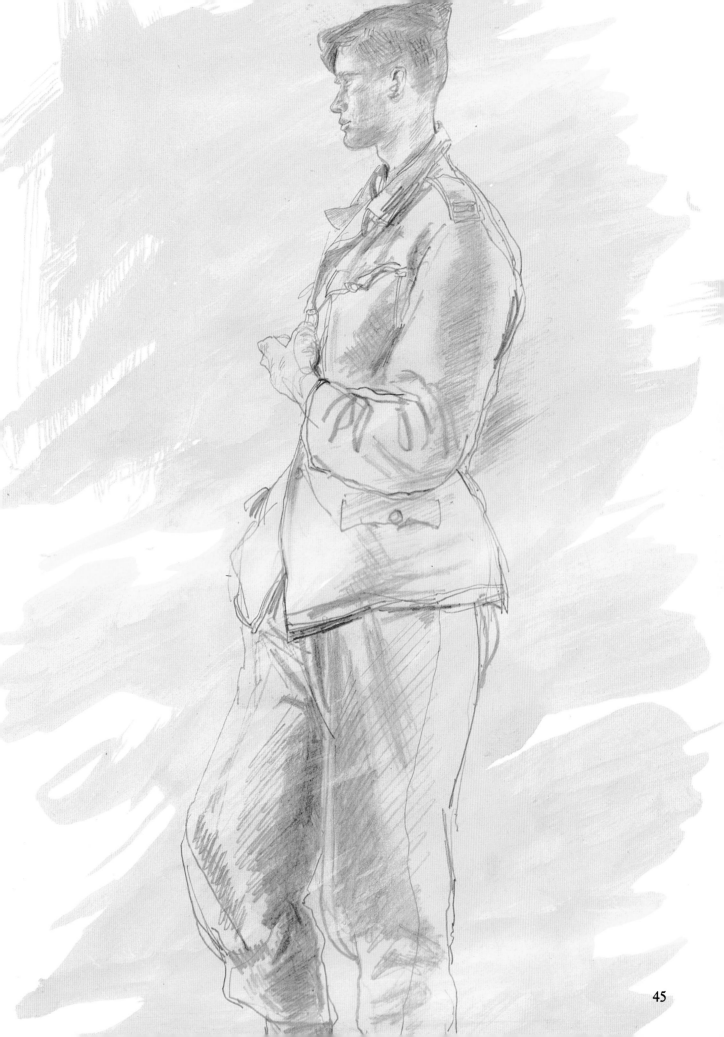

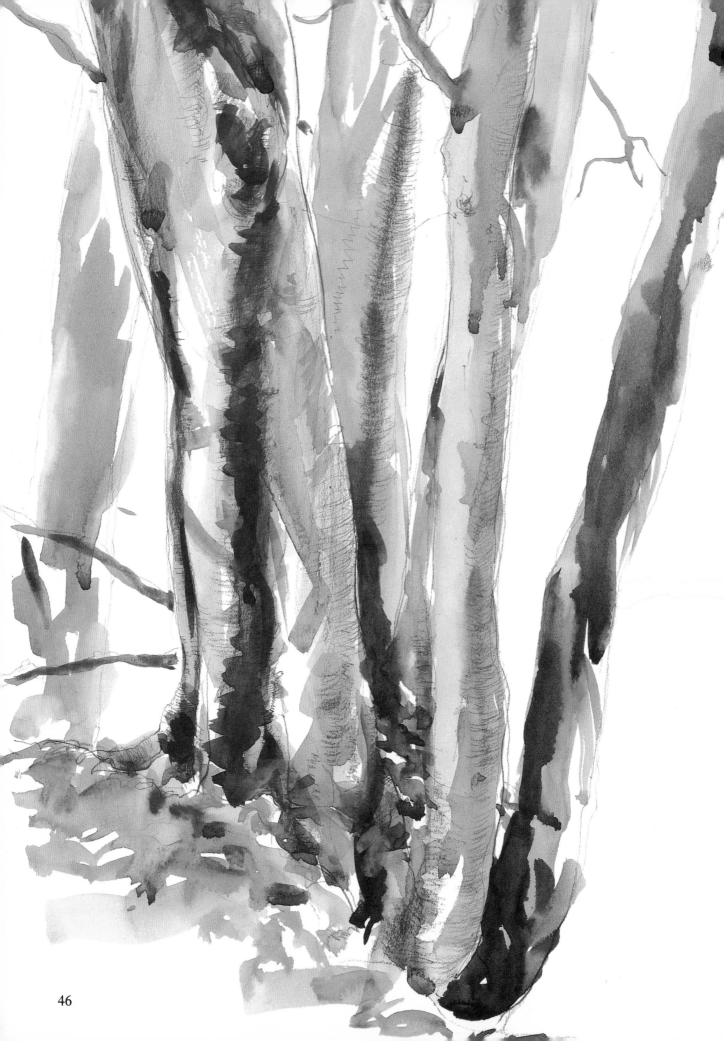

46

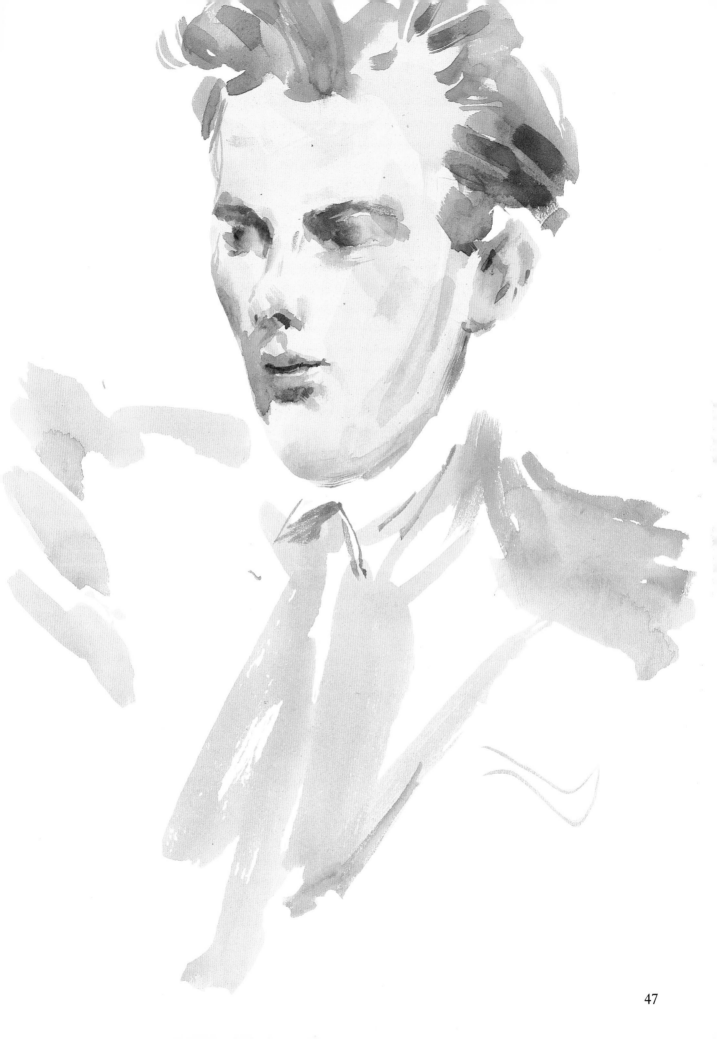

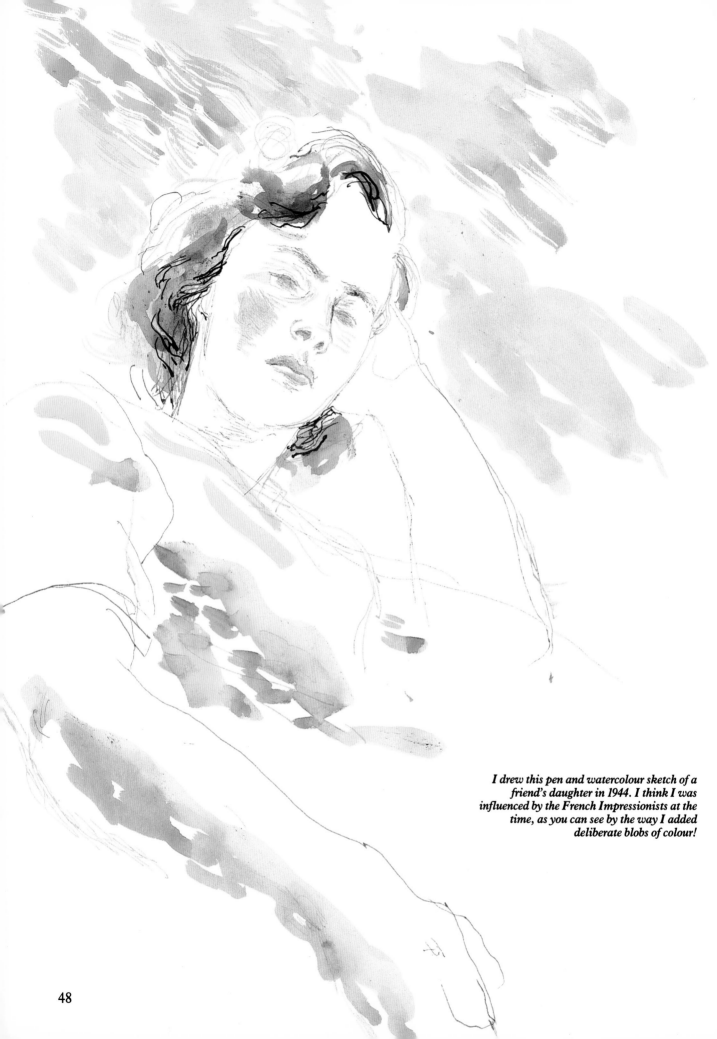

I drew this pen and watercolour sketch of a friend's daughter in 1944. I think I was influenced by the French Impressionists at the time, as you can see by the way I added deliberate blobs of colour!

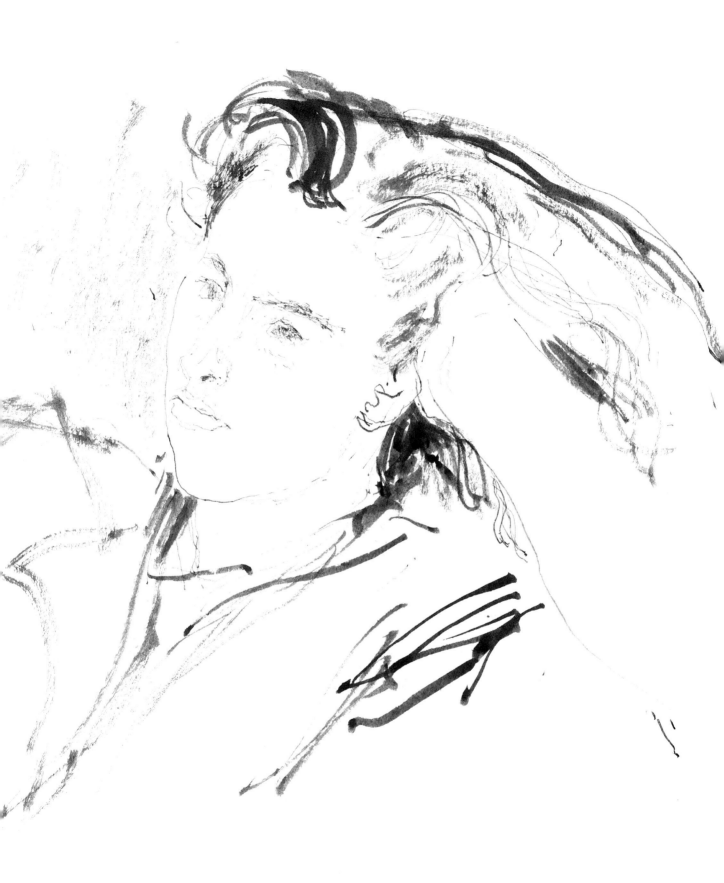

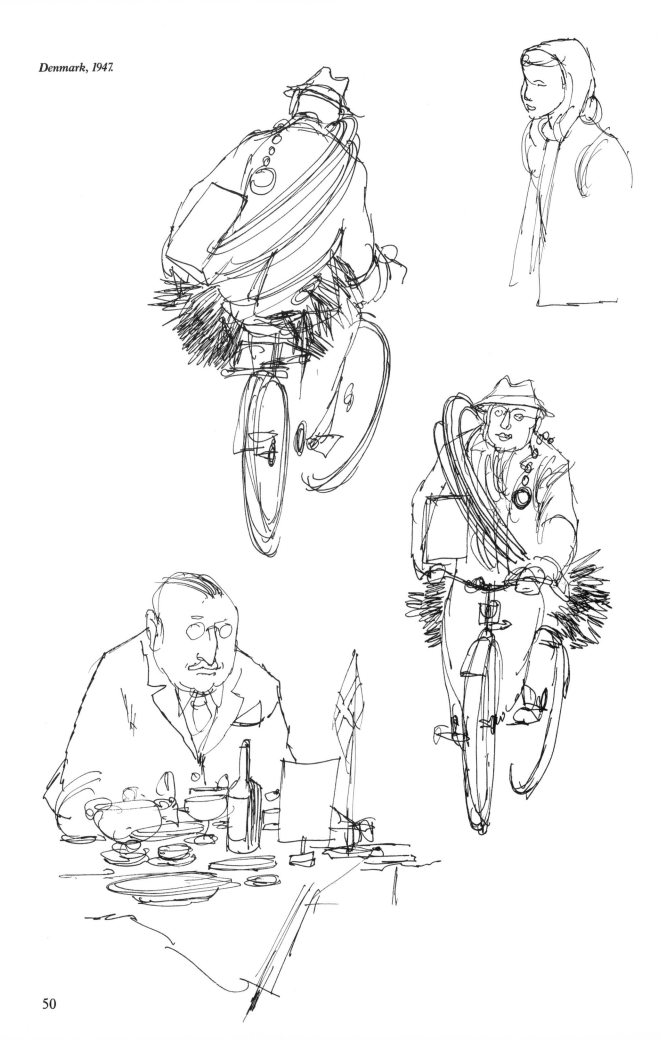

Denmark, 1947.

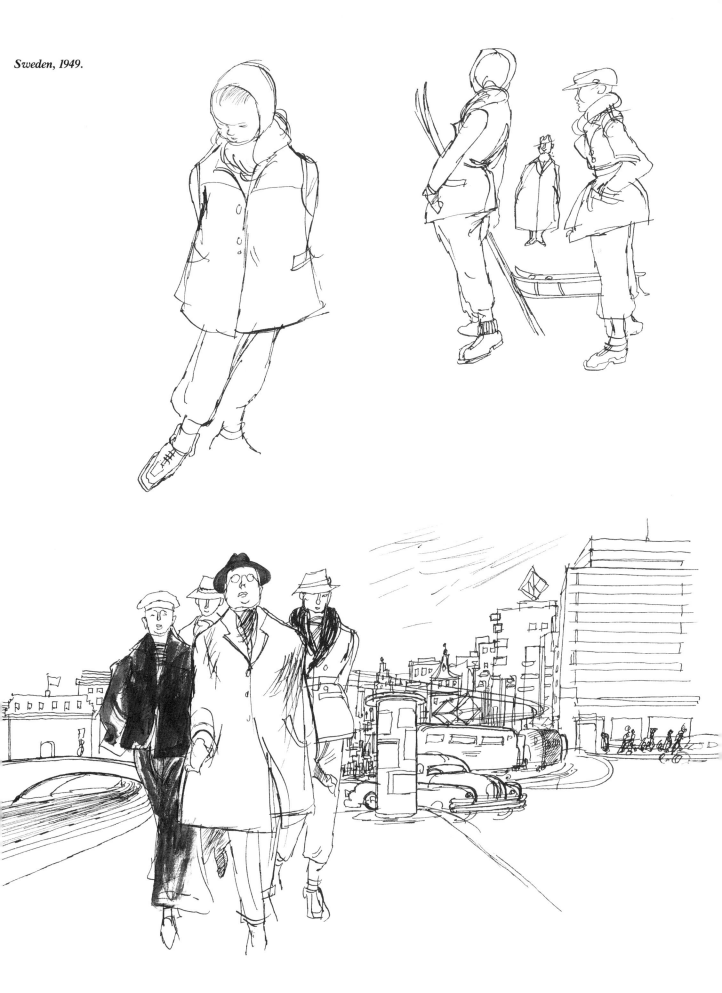

New York, 1951.

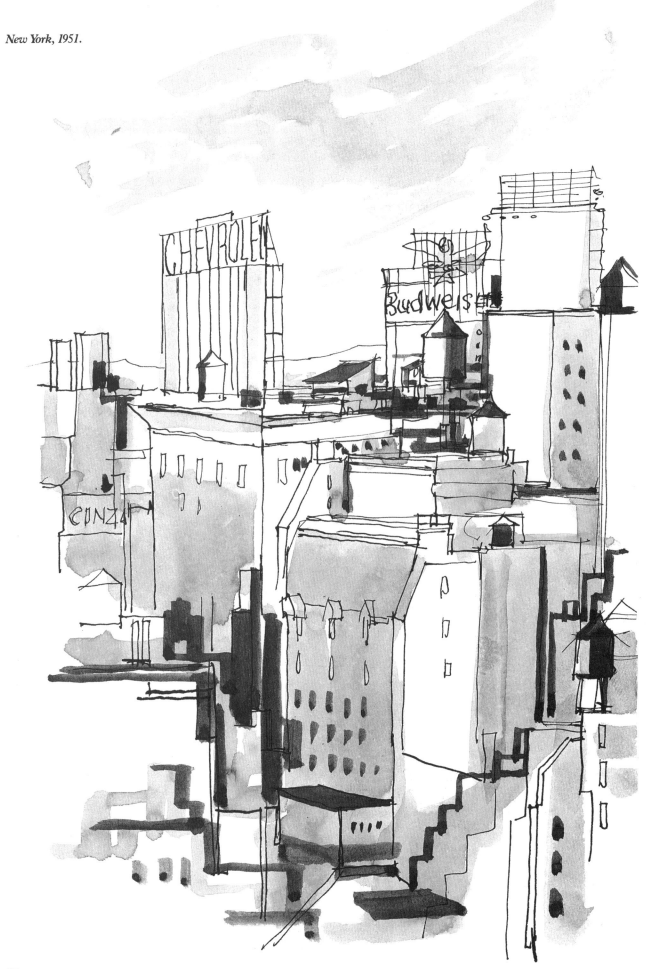

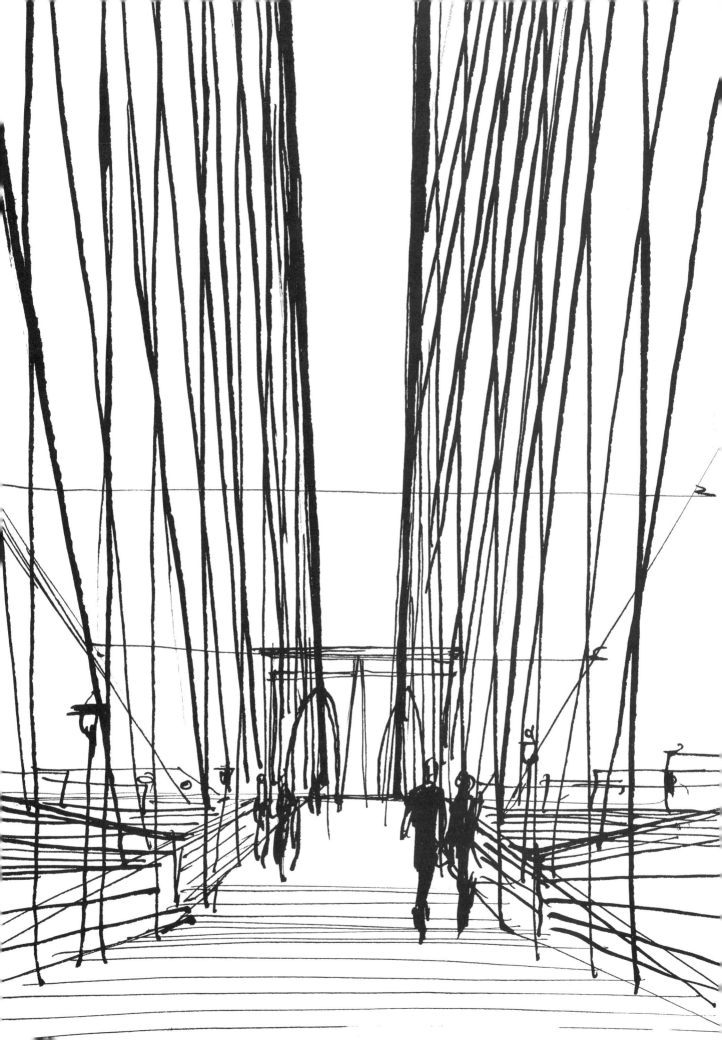

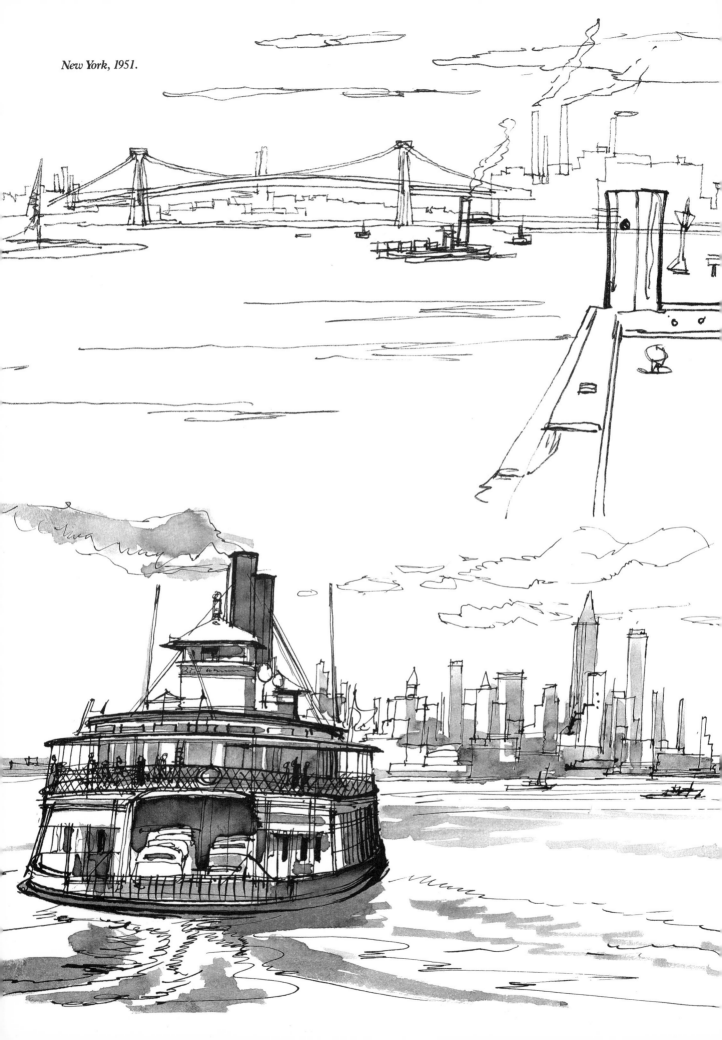

New York, 1951.

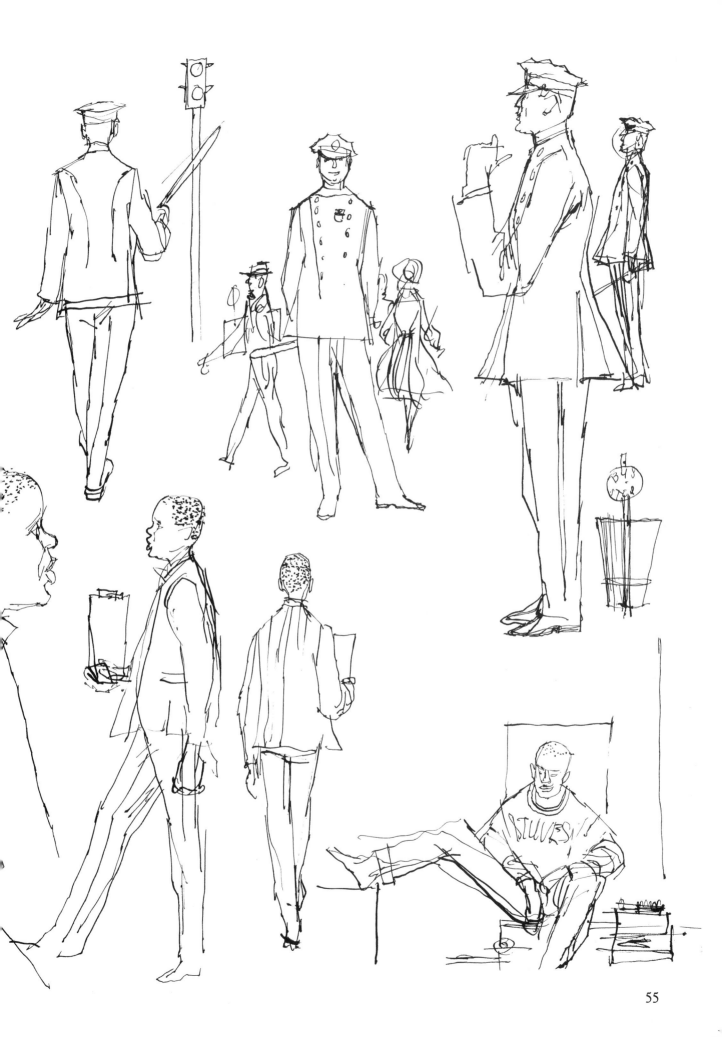

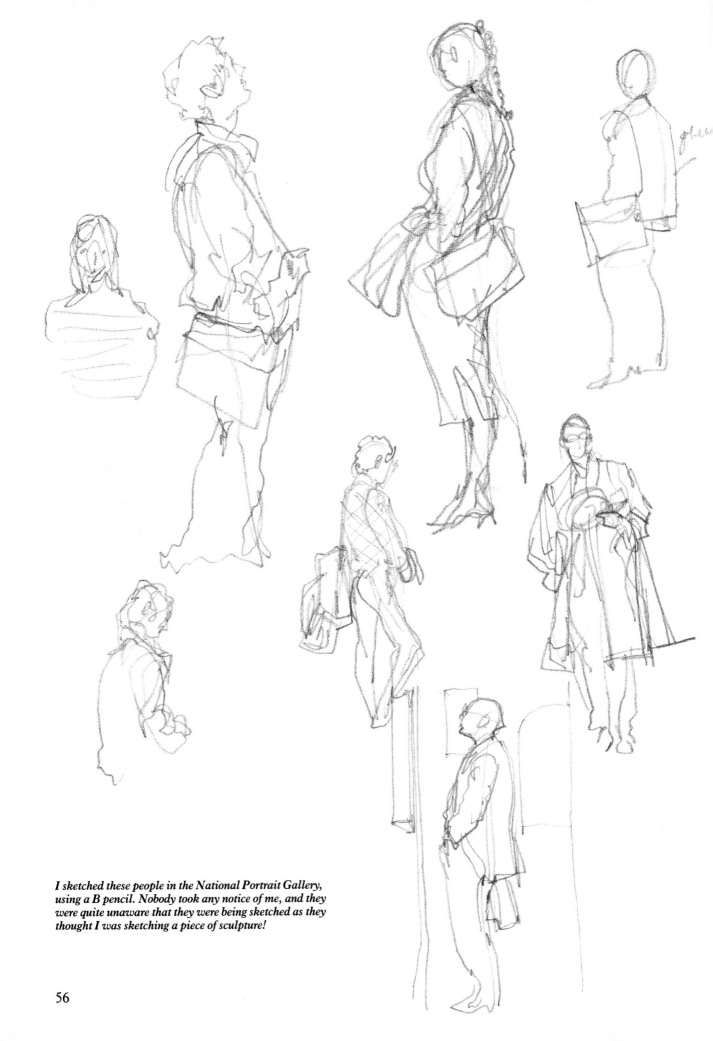

I sketched these people in the National Portrait Gallery, using a B pencil. Nobody took any notice of me, and they were quite unaware that they were being sketched as they thought I was sketching a piece of sculpture!

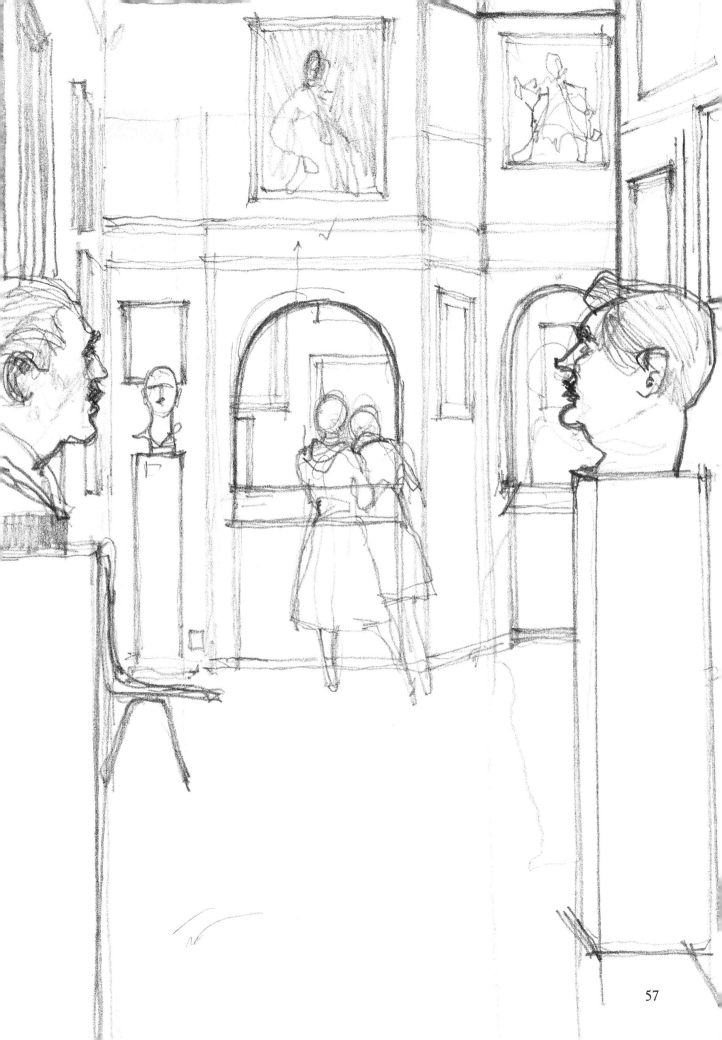

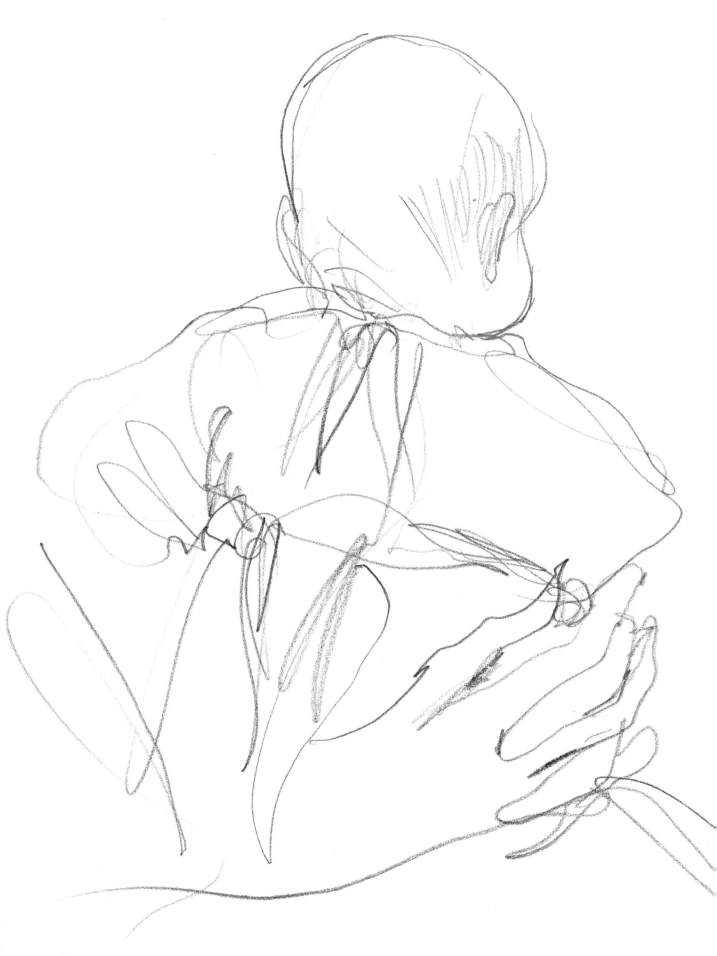

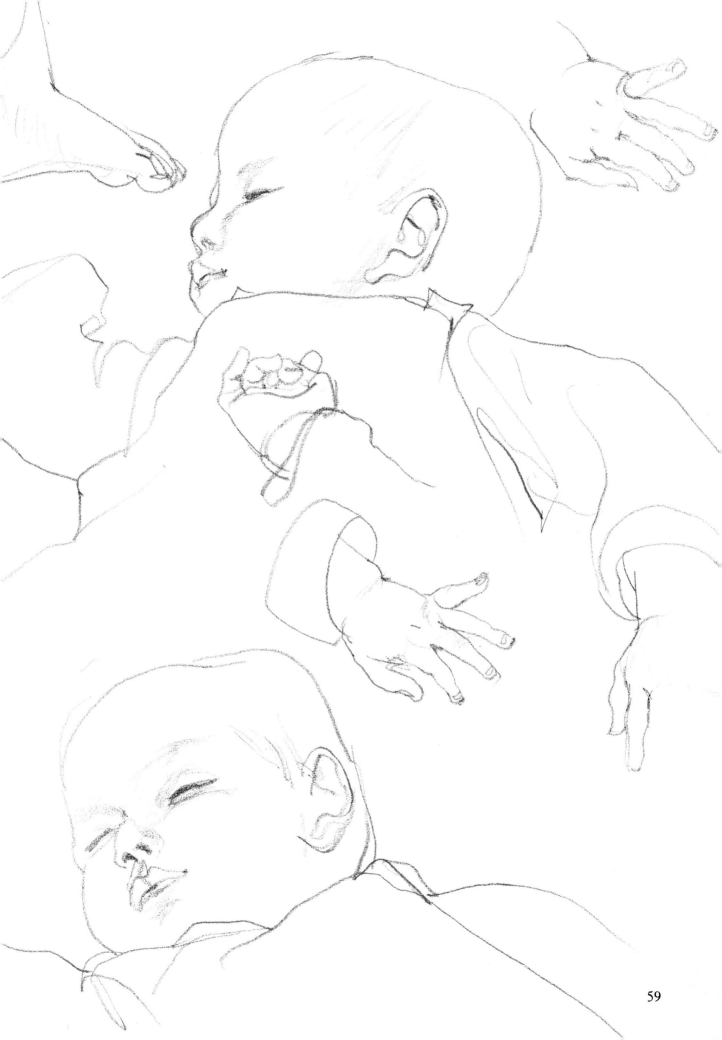

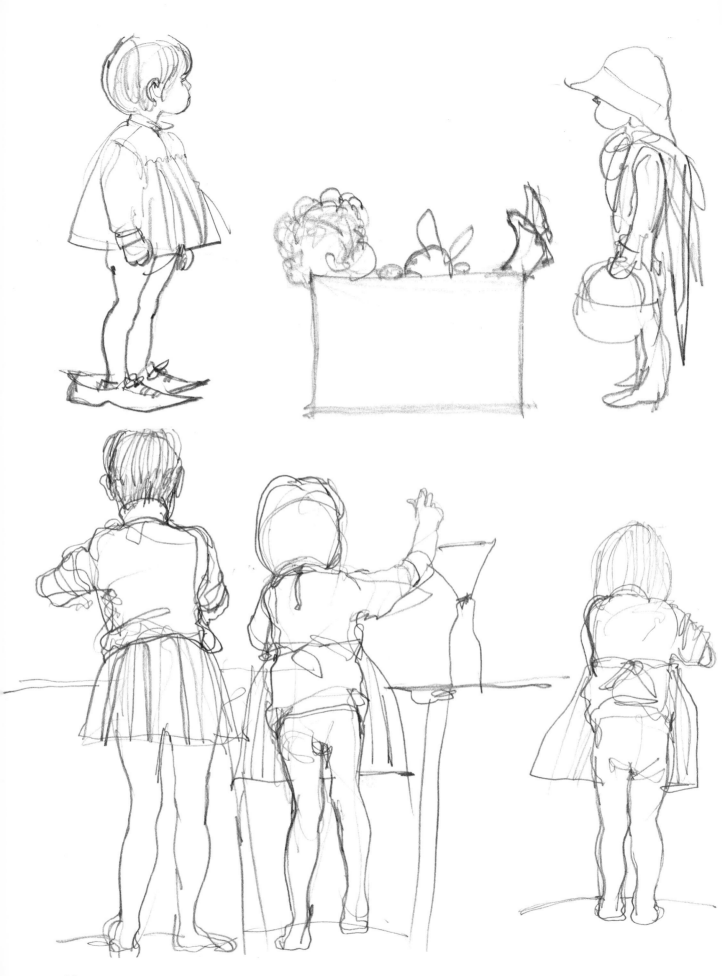

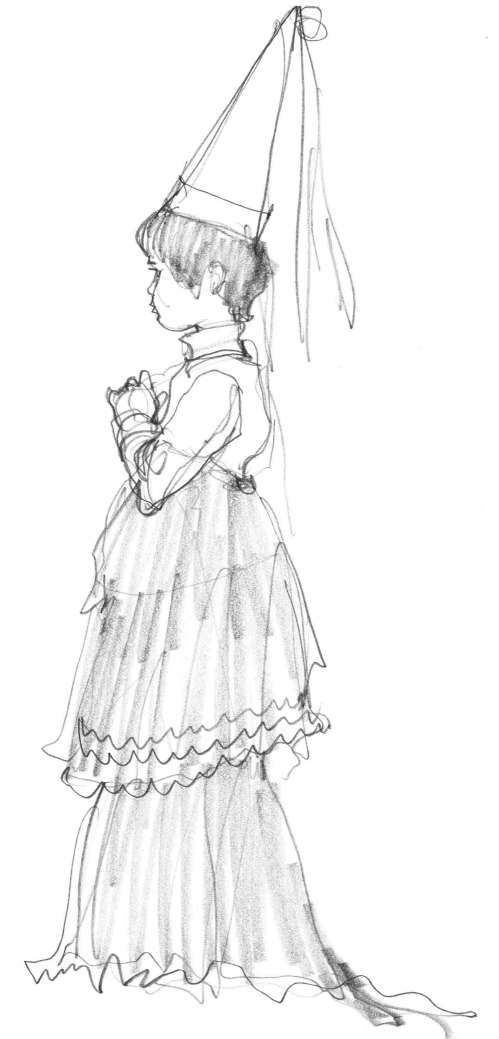

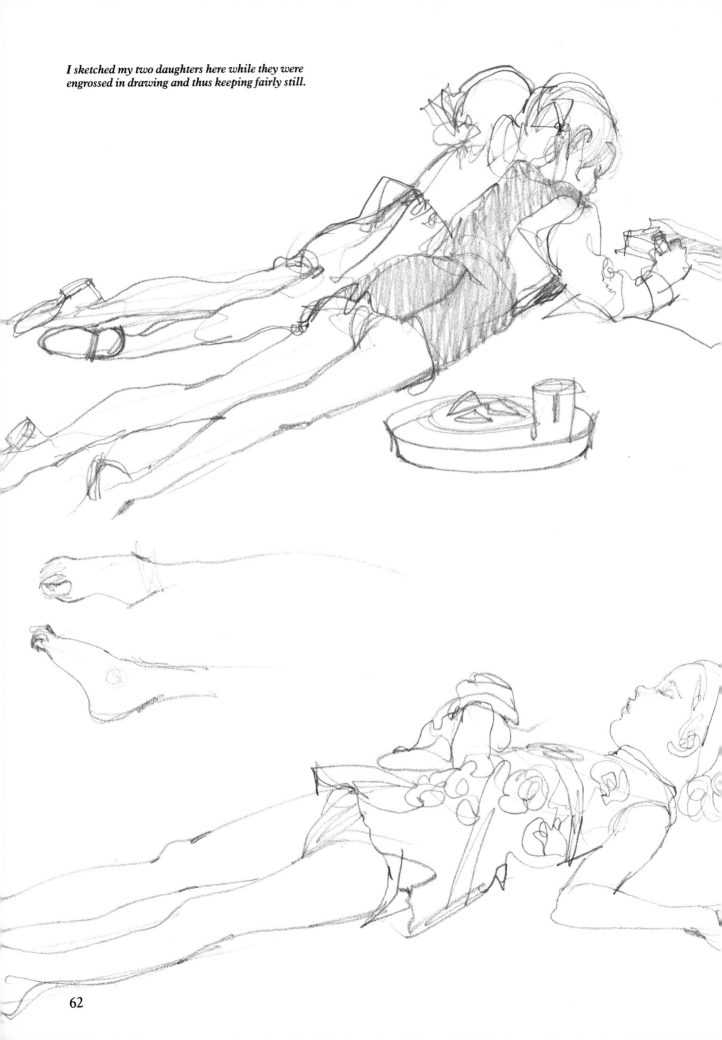

I sketched my two daughters here while they were
engrossed in drawing and thus keeping fairly still.

62

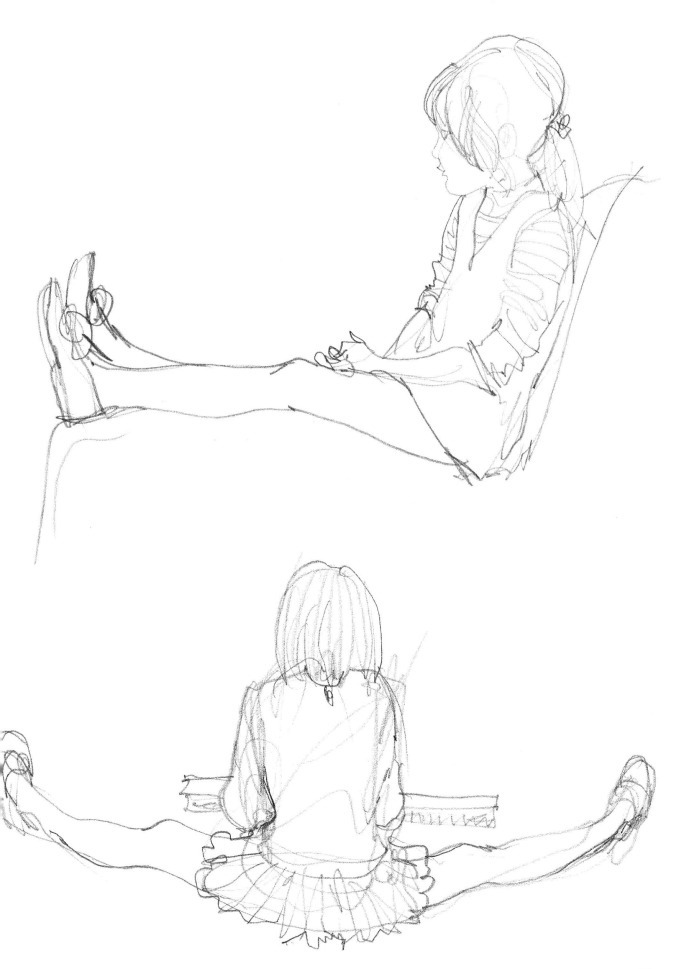

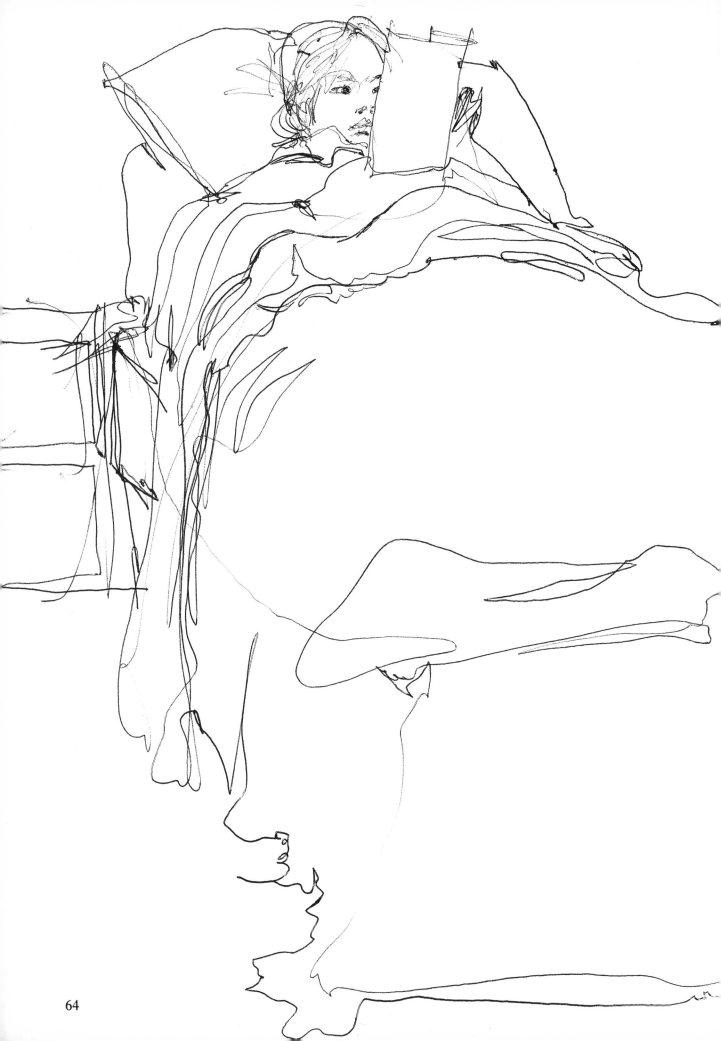